MW00803103

ECCENTRIC TALES
OF
BORING
OREGON

hope it's not too Boring!

BRUCE HANEY

Bruce Haney

**THE
History
PRESS**

Published by The History Press
Charleston, SC
www.historypress.com

Copyright © 2021 by Bruce Haney
All rights reserved

First published 2021

Manufactured in the United States

ISBN 9781467148351

Library of Congress Control Number: 2020951991

Notice: The information in this book is true and complete to the best of our knowledge. It is offered without guarantee on the part of the author or The History Press. The author and The History Press disclaim all liability in connection with the use of this book.

All rights reserved. No part of this book may be reproduced or transmitted in any form whatsoever without prior written permission from the publisher except in the case of brief quotations embodied in critical articles and reviews.

This book is dedicated to my mother and father, Pamela and Stanley Haney.

CONTENTS

CONTENTS

PREFACE

Despite what the name tells you, Boring has never been boring. The town, in fact, has a lot of interesting stories in its past—if you know who to talk to or where to look. Lucky for you, I have done all the legwork and research for you. I have talked to many of the long-term Boring residents, and I have spent more time searching newspaper archives than most people spend on social media these days.

In these pages, you will read about some of my favorite non-boring Boring stories. Exciting stories that I have come across in my years of researching the town of Boring.

My interest in the history of Boring started a few years ago. I had been working in the town for several years, and I started wondering how old some of these interesting-looking buildings were in the downtown area. The building that is now the Boring Bar, for example, intrigued me. With a bit of research, I found out it was known as the Morand Building. It is a square, flat concrete block building built in 1913. It was originally built as the post office by William Morand. From that bit of town history, my interest grew, and now, five years later, I am a walking encyclopedia of the history of the town of Boring.

When I first started doing this research, I wanted to share what I found online in case anyone else happened to be interested. My original thought was to create a blog. But I decided it would be better to create a Facebook group; that way, people could share and comment on what I post and hopefully add their own personal memories to the page. I could find out the

history of the town that was never documented. I did not think many people would join the group. But it has grown into its own community, and through it, I have become friends with many people in the town of Boring.

One Boring resident who was an early member of the group was Dan Bosserman, a fellow Boring writer. He liked the group and what I was sharing, so he asked me to take over the "Moment of Boring History" segment during the Boring Community Planning Organization's monthly meeting. This is what led me past just looking for the history of the buildings. That history is interesting to me and fun to talk about, and I do sprinkle a little bit of it into the stories in this book. But this monthly speech now gave me an audience, and each month I wanted to wow them and surprise them with stories from their history that they knew nothing about. The quest for stories made me up my research game, and I started searching deeper into the newspaper archives and visiting the historical museums in nearby towns.

The Sandy Historical Museum is an amazing local museum with great displays about the history of Sandy, and it has a vast amount of research material for the area. Its focus is Sandy, of course. But there is plenty of Boring information to find there if you know where to look. Hint: start with the Miles Aubin binders. Miles was the original town historian, and he is the reason I am never quite comfortable when people call me the town historian. I guess I am. Miles passed over ten years ago now. But I always think of myself as the current town historian. I have been doing this for five years, but Miles did it for decades.

I have found that all this research and sharing the history of our town has enriched my life. Through it, I have become friendly with the many other people in town who care about Boring—the theater people and members of the Community Planning Organization, the Boring Oregon Foundation, the Boring-Damascus connection and other local interest groups. When I started wondering how old that bar or that two-story brick building was, I never thought that it would lead to me finding and being welcomed into such a wonderful community. I grew up in the big city nearby, Portland, but I never felt part of a community there. In Boring, I do.

ACKNOWLEDGEMENTS

The number of books that get published without the help of other people is low. The number of books that involve history that are released without the help of many others is close to zero. This book would have been near impossible without the assistance of others.

First, I would like to acknowledge the benefit of writing this type of book in the digital age. When I read local history books that were published decades ago, I am amazed at how thorough and well researched they are. In those days, you had to go to different locations to gather your information. Many writers have spent hours and hours behind a microfilm machine looking for information on what they are writing about, without the aid of a search feature.

I have spent those hours behind my laptop searching the historic newspaper archives that are provided by the University of Oregon. I still spent hundreds of hours researching to build these stories. But being able to do it from my home and being able to use a search function is amazing.

Family Search has been a site that I used frequency to produce this book. Being able to look up the census records and find the history of these people helped me be able to tell a much richer story.

A local Boring resident I would love to thank in this book is Dan Bosserman, who always encouraged me and gave me the shot to tell the monthly history story. Working on those monthly speeches trained me well for this project. My research as well as my storytelling skills come from that experience.

Acknowledgements

I appreciate everyone at the Community Planning Organization—the friendly smiles, the critiques, the space to hone my craft and all the historic information that people have shared with me after the meetings. James Valberg, a member of that group whose family has a long history in Boring, was quite helpful for a few key facts on the stories that involve his family.

The Gresham Historical Society has been great, sharing a few of its photos for this book and letting me use its research room in the past. Thank you, Mark Moore, for your help.

The Sandy Historical Society has a fantastic museum in Sandy, and it has been such a wonderful source of information and pictures for this book. Thank you so much to Ken Funk for all your assistance, as well as Ann Marie Amstad. Also, thanks to Miles Aubin and Phil Jonsrud, who are no longer with us but contributed so much to the history archives of this area.

Thanks go out to my family, friends and to Rachel Rogers for their support during the writing of this book.

INTRODUCTION

Before we get to the stories, I want to give you a brief history of the town of Boring, and I will start with the question everybody always has: why is the town named Boring?

The town of Boring is named after William H. Boring. Before I get to the why, let me tell you the history of the man. William was born in 1841 in Greenfield, Illinois. He was an American Union soldier. He joined the Thirty-Third Illinois Volunteer Infantry Regiment at twenty years old. During the Siege of Vicksburg, he was wounded in the face and neck. After being discharged from the war, he wore a beard to hide the wounds he had taken to the throat and face during battle. He would wear a beard for the rest of his life.

In 1867, William married Sarah Elizabeth Wilder. They spent the first seven years of their marriage in Illinois before deciding to go west in 1874. When they went west, the Oregon Trail was no longer the only way to get to Oregon. William and Sarah decided to take the train to San Francisco. From there, they took a boat to Portland. Once in Oregon, the couple moved onto the property that William's brother Joseph Boring had homesteaded. In 1883, when their son Orville was four and about school age, William and Sarah donated land for a school to be built. Because of their generosity and there being no other landmarks in the area, people passing through started referring to the area as Boring or, as the *Oregon City Enterprise* called it, Borings. That is how the town got its name.

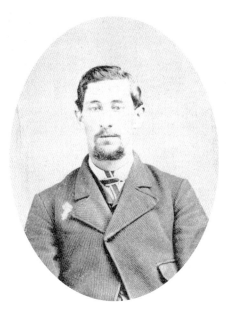
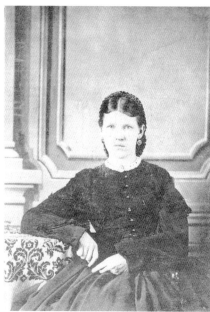

Left: An early photograph of William Harrison Boring before he moved to Oregon. *Courtesy of Sandy Historical Society.*

Right: Sarah Elizabeth Boring, wife of William H Boring. *Courtesy of Sandy Historical Society.*

Other early Boring residents were the Vetch family. Matheus and Elsbeth Vetch were in the area so early that the name Boring hadn't quite stuck yet. They had moved from Switzerland to the United States in 1878. Once in the country, they, too, made their way via train to Oregon. They bought 160 acres of land from Joseph Boring. They had moved into the area before the Boring School, so they named their company Damascus Creamery after the closest town to them, Damascus.

Their original house burned down years later in 1917. But they were doing well enough in their dairy business to afford a new house and to have the Meir and Frank Department Store furnish the whole place—furniture, bedding, china, glasses, towels, pots and even decorations. Matheus was good friends with one of the owners, Mr. Meier.

The next growth period of Boring started in 1902. The *Oregonian* ran an article titled "New Town Springs Up." It said that "a new town to be called Boring has sprung up in the very center of a belt of heavy timber on the line of the railway. Two months ago the wilderness there was unbroken, except by the wagon road through it. A first-class sawmill capable of cutting 50,000

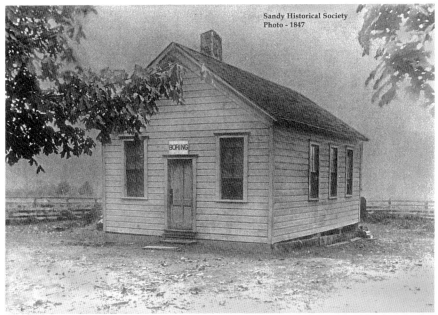

Sandy Historical Society
Photo - 1847

BORING

Original Boring Schoolhouse built in 1883 when William H. Boring donated land for the school

One of the oldest photos from Boring. Since the school was on donated land from William and Sarah Boring, it was named after them. *Courtesy of Sandy Historical Society.*

feet of lumber a day, is now in operation sawing lumber for the buildings already going up."

Orville Palmer owned that mill; he moved his operation from Pleasant Home to Boring. His brother Loring was also running a successful mill in Bridal Veil at the time.

The Oregon Water, Power & Railway Company built a line that would pass directly through Boring and moved and rebuilt a steam power station from Inman & Paulsen's mill as part of the new railway system. The building was 108 feet long and 42 feet wide. The sawmill and power plant would be mutually beneficial; the mill and lumber yards were now lighted by electricity, and the power plant used sawdust and slab-wood for fuel from the mills.

The main townsite at this time was owned by Orville Palmer and James Roots. James Roots built a store around this time that is no longer there. It is unknown what happened to that store. In 1906, he built J.W. Roots Merchandise, and that building still exists in the town. In 1910, he sold it to his son-in-law, and it became W.R. Telford's General Merchandise. Thirty years later, Telford would sell it to E.F. Sutton. Between 1940 and 1974, it

Left: Early Boring residents Matheus and Elsbeth Vetch. *Courtesy of Sandy Historical Society.*

Below: Damascus Creamery truck in front of its Portland facility. *Courtesy of Sandy Historical Society.*

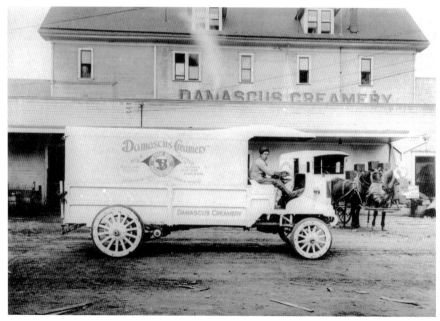

Loring Palmer's mill in the nearby town of Bridal Veil. Not much of the town exists anymore except for a small post office that stays in business from the thousands of couples each year who send out their wedding invitations from there so they are postmarked from Bridal Veil. *Courtesy of Sandy Historical Society.*

changed names a couple of times. For a period, it was called the Country Store. Then for a while, it was called the Boring General Store. But in 1974, Dave and Yvonne McCall bought the store and renamed it McCall's—a name that has lasted over forty-five years and continues today.

In January 1903, the new town of Boring petitioned for a post office. The original post office location is unknown. But from 1906 to 1912, it was in the store built by James Roots. It was run by his daughter Amy. She was married to William Morand, who built the new post office in 1913. In 1932, the post office moved to the brand-new Valberg Building. The Morands sold the old post office building to Henry Kimbell, who turned it into a tavern. The building has continued in that capacity ever since. After Henry Kimbell's time with the building, it became Jay's Tavern, and at one point it was called Barb's Tavern. For many years, it was called the Boring Tavern before changing hands and becoming the Full Moon, the Not So Boring Bar and, most recently, the Boring Bar.

Many businesses have come and gone over the last hundred-plus years of Boring history. In those early days, we had a Van Dolin's shoe shop, a dance

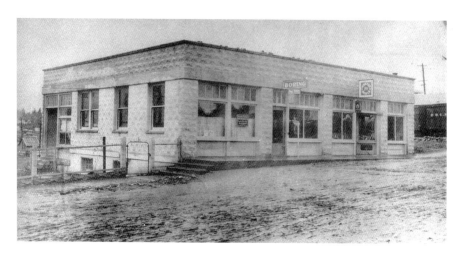

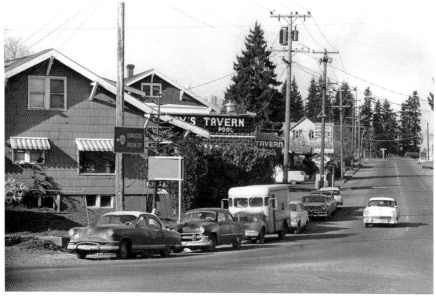

Top: William Morand built this building in 1913. One side was for the post office and one side for Morand Drug Co. *Courtesy of Sandy Historical Society.*

Bottom: Beautiful old cars line the street in front of Jay's Tavern. *Author's collection.*

hall, a pool hall, a confectionery, a picture studio and even a short-lived theater. Most of those businesses I found out about in an article about them burning down in the great 1922 firecracker fire, which you will read about further in this book.

That is the brief history of the town of Boring. I have enough information that I could write a whole other book on just the dry history of this town, and maybe someday I will. But this is not that book. This book is about the exciting stories that happened in Boring—stories about explosions, moonshiners, wild men who live in the woods, fires, train shootings and even a short-lived gang. I hope you enjoy reading these true Boring stories, and I hope that next time someone makes a joke and asks you "How boring is Boring?" you will be able to tell them how truly un-boring Boring is.

PART I

BORING PEOPLE

Chapter *1*

THE PRIZEFIGHTER VERSUS
THE BORING BOXER

There are no pictures of Free Coldwell. But the *Sunday Oregonian* did a wonderful job describing the man in its newspaper in 1905. Coldwell was described as red-headed, arms like a gorilla, heart like a snail and the punch of an infant. The "punch like an infant" part might not be completely accurate. Because that same article that describes how much of a pest Free Coldwell was to the town of Boring also talks about how he swaggered around town looking for fights, telling everyone he was a prizefighter and how he had "walloped" many Boring "Fistic aspirants" into dreamland. If he was walloping all these people into "dreamland," he must have had more than the punch of an infant.

But the paper was right; Free Coldwell was no prizefighter. First off, there is no record of a prizefighter named Free Coldwell. Second, there is not even a mention of a Free Coldwell in the census records. This man was phony, and if he was a prizefighter like he said, then he was using a fake name around Boring.

The people of Boring quickly got sick of Coldwell's antics and cooked up a scheme to get rid of this man who was becoming quite the pest to them. The seed of the plan came to the townsfolk of Boring when many of them read in the newspapers about the up-and-coming boxer named Tommy Burns. Tommy was training in the Portland area for an upcoming fight against Jack "Twin" Sullivan. Jack was named "Twin" because his brother Mike was also a boxer, and they looked nearly identical.

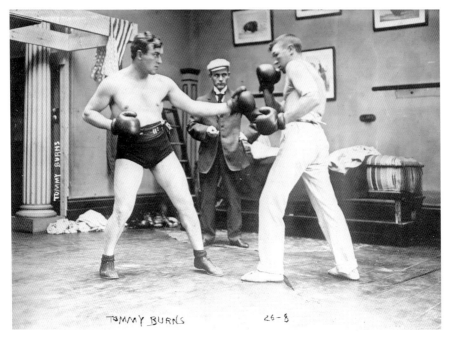

Tommy Burns in training, getting ready for a match. *Courtesy of the Library of Congress.*

Tommy Burns's birth name was Noah Brusso. He was born in 1881 in Ontario, Canada. In 1900 at the age of nineteen, he started boxing in Detroit, Michigan. It was not until 1904 that Noah Brusso started boxing under the name Tommy Burns. Tommy was not a huge guy; he was sometimes called the Little Giant of Hanover. He was 175 pounds on a five-foot, seven-inch frame. That being said, he was still an impressive boxer. At the end of his career, he had forty-seven wins to four losses.

Tommy was a socially aware man for his time. In an age when most boxers would only fight in their own race, Tommy would fight anybody. He said that he wanted to be the champion of the world, not just the white champion or the Canadian champion. In this prejudiced age, he would fight all challengers. He fought Black people and Native Americans, and he was the first person in his class to take on a Jewish challenger when he fought Joseph "Jewey" Smith at the Neuilly Bowling Palace in Paris.

After reading about this prizefighter training in Portland, the townspeople of Boring decided to reach out to him to see if they could convince him to fight their "prizefighter." That way, they could prove once and for all that Coldwell was not the real prizefighter he claimed to be and that he was just

a phony. They thought that if they were lucky, he would get such a beating that the brute would leave town.

Tommy Burns agreed to the townspeople's request to fight Free Coldwell for reasons unknown. Tommy was a real prizefighter, and this fight seems like a waste of his time and talent. The purse for the winner was only $4.90; back then, that amount had the spending power of what $120 has now. It is not nothing, but for him to take the train all the way out to the town of Boring for $120 when he had training to do—was it worth it? Maybe Tommy Burns did not like the idea of this guy pretending to be something that Tommy Burns had to work so hard to be. Whatever his reason, Tommy Burns, a real prizefighter, came to Boring to fight Free Coldwell the wannabee.

The townspeople gave Tommy Burns one rule he had to follow for this fight: do not kill Coldwell. The townspeople made this request because they did not want to have to pay the expense it would take to bury him.

Boring, Oregon, is not a town that comes to your mind when you think of boxing. In fact, this is the only match that ever happened in the town of Boring. Since Boring never had a boxing match before, this meant that Boring did not have a boxing venue. Boring did have an opera house though—well, a building they called the opera house anyhow. It was just a place for events and dances. The opera house also had the convenience of a wooden walkway that leads to it from T.M. Allison's Saloon.

It was said that over one hundred people from Portland traveled out to Boring for this fight. Most of the people probably traveled by train, stagecoaches and horses. In 1905, automobiles were around but were not common yet. The town of Boring must have been overwhelmed. It was not set up for this many out-of-town visitors. Did they have enough hitching posts for this sudden influx of horses? Could T.M. Allison keep up with that many thirsty patrons?

The town had to build its own ring. Spectators commented that it was quite small and was not big enough to hold two infants. Tommy Burns himself said that he was afraid he was going to fall through the floor.

Even though one of the fighters was not really a prizefighter and this was not taking place at a real event center or in a real ring, it did not change the excitement level of the crowd. Some even thought this was two prizefighters going at it. But most were there just to see Free Coldwell get his.

The townspeople told Free Coldwell that the boxer's name was Mr. Brusso. They were afraid that if he did know anything about boxing, he might know who this quickly up-and-coming boxer was.

When Free Coldwell saw "Mr. Brusso" for the first time, he was not impressed. Tommy was a good forty pounds lighter than Coldwell. Free declared to anyone in earshot that "I could whip a whole Clackamas County of Mr. Brussos." He was also heard telling his friends that he would beat him in "jig" time.

The location and set-up might have been unprofessional, but this was going to be a fair fight, and the townspeople hired a boxing referee to make sure of it. His name was Tom Tracey. He was an Australian-born man who was on the tail end of his own boxing career. His first known match was in 1891.

With the fight getting ready to start, the finances had to be decided on. There was of course the $4.90 to be won. But there was also the cost of renting the hall, which for some reason was not paid for by the town but was to come out of the winnings. The fighters were asked if that was agreeable. Free Coldwell did not like the idea. He said that the winner should get it all and the loser should pay the cost of the hall—all $0.75 of it. Tommy Burns was fine with this arrangement. He had no fear that he would be the one paying the $0.75.

Free Coldwell was wrong in saying that he would beat Mr. Brusso, aka Tommy Burns, in "jig" time. This fight ended up going five rounds.

The first three rounds were nothing special. Mr. Brusso let Free Coldwell get in some hits and even pretended to be hurt. He even went down a few times to keep the gag going. The parts of the audience who knew that Mr. Brusso was really Tommy Burns howled at this, loving the show that Burns was making of the fight.

In the fourth round, Tommy Burns must have decided he had played with this wannabee pugilist long enough because it was in this round that Tommy hit Free Coldwell for real for the first time—square in the nose. Blood came seconds later. The newspaper reported that it was a shade darker than Free Coldwell's red hair.

This is the moment that Free probably realized he was in trouble and he might just be fighting someone much better than himself.

In the next round, Free Coldwell showed his cowardice. The very next time "Mr. Brusso" hit him in the stomach, he was out of the ring, declaring that you cannot hit a guy in the stomach. "That is not fair," he yelled at the referee.

Tom Tracey, the referee, was furious at this and told Free Coldwell that he had two minutes to get back in the ring or "Mr. Brusso" would be declared the winner.

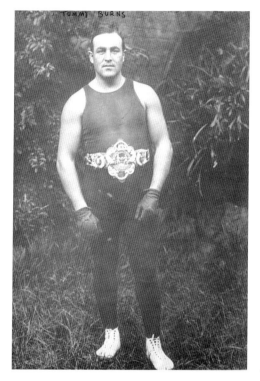

Tommy Burns proudly wearing his championship belt. *Courtesy of the Library of Congress.*

The clock was started, and the crowd waited with anticipation. The townsfolk had put a lot of effort into this fight. They did not want Free Coldwell dead, but they did want him maimed. A bloody nose and a punch to the stomach did not live up to the beating they had plotted for him. But the clock ran out, and Free Coldwell did not get back in the ring.

Tommy Burns was declared the winner. The townspeople were happy about that, and they hoped that this would rid them of their town pest. It might just have because there are no more references to Free Coldwell harassing the town of Boring ever again.

This was a very minor fight in the career of Tommy Burns, and the town of Boring was quite lucky to get a boxer of his caliber for this event. The next year, Tommy fought Marvin Hart. Marvin Hart was the current heavyweight champion of the world at the time of the fight. The prize for that fight was much more than $4.90; it was $1,650. Tommy Burns fought Marvin Heart and won, which made Tommy $1,650 richer and made him the world heavyweight champion, a title he held for two years.

Chapter 2

THE WILD MAN

The weather had finally starting to warm up. The previous week's snow was melting away from both a rise in temperature and a high volume of rain. This change in weather must have been welcomed by Daniel Clifford, who had been living in the woods between Boring and Kelso during the winter of 1916. The rain may have been a burden. But when you are living in the woods naked, rain is better than snow.

Constable Jack Frost and Sheriff William Wilson were looking for Daniel. Jack Frost had been a constable for only a few years. Before that, he had been a juvenile officer for six years and a police officer for two. Jack was a morally righteous man who held firm to his values. He once tried to get an anti-cigarette measure going, but it had failed. He was successful at making a skating rink close on Sundays though. Sheriff Wilson did not have such strong opinions, and he and Jack had a little public feud that was published the previous year in the *Oregonian*. It was an article about how Mayor Jones and Sheriff Wilson did not seem to care about people getting caught "spooning" in the park. But Jack, irritated at the mayor and Sheriff Wilson, said that if he found lovemaking late at night by persons underage, he would intervene. Another quote from him said, "It's about time the officials of Oregon City were coming to their senses, a public park is not a proper place to spoon."

When Jack and William went looking for the man living in the woods, they did not know his name. They only knew what the townspeople called him: the Man-Woods-Nymph and the Wild Man of Kelso. Kelso was a small community a mile from the main town of Boring, but now it is considered

part of Boring. Back then, when it took more effort to get around, it seemed like every mile was a different town with a new name. In the early twentieth century, there was Boring, Kelso, Haley and Barton, but now they are all considered Boring. Barton still has the Barton Store and Barton Church, but they all have Boring addresses.

During his time in the woods, Clifford was spotted by many people walking around naked or with limited clothes on. It was said that this wild man was dirty and unkempt and that his lack of clothing frightened the local women and children. Nobody knew who he was or where he came from. Most people would not go near the man. To them, there was suddenly this strange nude man living in the woods in their town from who knows where. They saw it as a scary situation. If this man was walking around naked in the middle of winter, then something must have been wrong with him. What else would a man like that be capable of?

Some people had tried to reach out to the man. They tried to convince him to get help, and some even offered him a place to stay. The wild man's only response to this was running away and hiding in the deep brush until the people had left.

The townspeople of Boring were curious about what he was eating to survive. It was rumored that he was surviving merely on roots. Whatever he was eating, it was not much because he was emaciated when he was finally taken in. Later, it would be found out that he was mostly eating potatoes and berries.

The people of Boring may have tried to reach out to the young man. But they did not try all that hard. It was not until local barrel maker Saul Garrison went out to Oregon City to file a formal complaint that anything was done to help him. Saul told the police officer that the man was "Nuts! And if you do not do something about it soon, he is going to end up dying in those woods."

A lunacy warrant was written so that the wild man could be brought in. The newspapers wrote that Sheriff Wilson and Constable Frost entered the woods armed with a suitcase full of clothes. They had heard that the man had been roaming around the road more and more and had hoped to find him near the road. But they were not that lucky. After they searched up and down the road without finding him, they had to wander into the woods to search for him.

After searching for a while, they stumbled across an old woodchopper's shack. When they entered the shack, they found a young man in a torn, dirty shirt wearing overalls that barely hung on his emaciated body. Garrison,

who reported the man to the sheriff's department, was right. If something had not been done soon, he would have surely died. When they found the Wild Man of Kelso in that cabin, he could barely move from lack of food. The sheriff and constable dressed him in warm clothes before taking him out of the woods.

He was brought to the hospital ward at the jail, where they worked on "feeding him up." As he got some food in him, he started to feel better. Once he seemed OK enough, he was questioned, but they found out little. They learned that his name was Daniel Clifford and that his family was from Massachusetts. He also told them that he had been living in Boring for only a couple of months. They kept questioning him to find out more information about him. During their questioning, they asked him, "Why are you living in the woods?" "Where is your family now?" But whenever they pressed, he would start to rave, and all progress would be lost.

Daniel Clifford—if that was his real name—is never mentioned in the Oregon newspaper archives after this. So it is unknown if his full story was ever revealed. The closest explanation for his behavior was written in the *Eastern Clackamas* newspaper, but really it was just a joke. "Just as a surmise, which may help solve the mystery, it is barely possible, the poor fellow had just paid his current taxes and his bare hide was all he had remaining and the insanity may have developed, following an attempt to thread his way up the famous Boring Hill Road."

ODD FELLOWS

On the outskirts of the town of Boring sat an old two-story building with the letters "IOOF on the front of it." IOOF is the acronym for a fraternal organization called the Independent Order of Odd Fellows.

In this building, there were some things that some people may consider strange or even odd. There were robes and costumes hidden away in closets. There were posters with strange symbols on the walls—symbols like the all-seeing eye, three linked rings, an axe, a heart in a hand and even a skull with crossbones.

In this building, the members would have secret meetings where any person wanting in would have to provide a password first. The members had a secret handshake and even had secret rituals they performed while wearing the robes and costumes. The specifics of these rituals could only be known by those who have been initiated and have been through the various rituals that they call degrees.

The lodge was instituted in January 1913. The lodge number was 234 since it was the 234th lodge instated in Oregon. When the lodge was installed, the members did not have their own building. In March of that year, they made a deal to rent the top floor of a building that already had a history in Boring. That building was originally built as the Boring Hotel, and then it became a saddle shop owned by the Herz brothers. The Herz brothers called their shop A.J. Herz Shoe & Harness Makers. The Odd Fellows sectioned the top story into two sides. One side was the lodge, and the other side was a banquet hall.

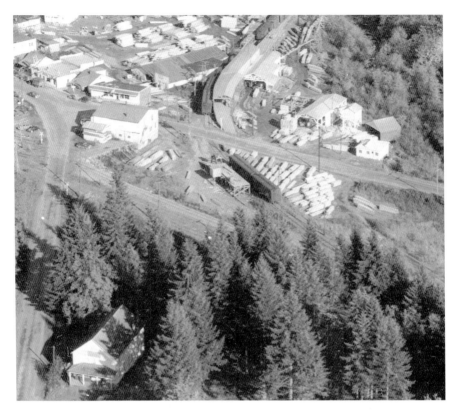

An aerial photograph of Boring. In the lower left corner is the Odd Fellows building. The Odd Fellows had this building for forty years, but this is the only known photo of this building while they occupied it. *Courtesy of Sandy Historical Society.*

The Odd Fellows had a sister fraternity that shared their lodge hall in Boring called the Rebekahs. Its lodge number was 213. They, too, had their own rituals, dress and symbols. Their symbols are the Beehive, the Dove, the Lily and a symbol of the Moon and the Seven Stars. A big deal was made when the Rebekahs were instituted in Boring in December 1913. The president of the Rebekah assembly was Charlotte Woodman, who was born in 1863 in England but moved to Portland when she was three. She came out for the installation of the new lodge. With her, she brought seventy Rebekah members from the Portland area. Since they were such a large group, they hired a special railroad car for the trip out to Boring.

In 1916, the Odd Fellows bought the building from the Herz brothers. Now that they owned the property, the Odd Fellows were quick to remodel the building to their needs. First, they extended the lodge room to take the

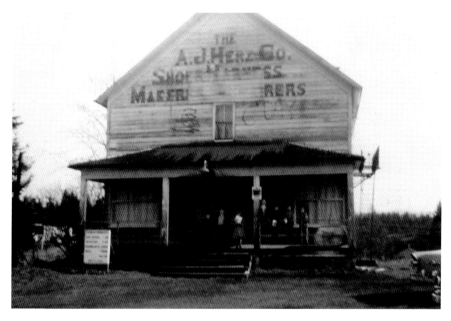

When the Boring Assembly of God Church owned the building, they did some remodeling. While working on the front of the building, they exposed the painted-on lettering from when the Herz brothers owned the building forty-plus years earlier. *Courtesy of Living Word Fellowship.*

whole top floor. Then they used the bottom floor for the banquet hall and a place for public meetings.

The early members of the lodge read like a who's who of Boring's past. Two of the most prominent long-term members of the lodge were the Morands. Amy and William were married on Thanksgiving in 1904. The wedding was held at her parents' house. Amy was dressed in white with orange blossoms. The house was decorated for the occasion with chrysanthemums, carnations and evergreens.

The year the lodge was established, William Morand was a district grand master in the Odd Fellows. He was educated in Portland at Homes Business School. In the Boring Lodge, he was the secretary. Outside of the lodge, he was the postmaster of Boring from 1912 to 1928. He was the town druggist; he had a storefront attached to the post office building with a sign that said Morand Drug Co. Later in life, he was the grand secretary for the Oregon Independent Order of Odd Fellows. In addition to that position, he was the secretary for the Oregon postmasters from 1908 to 1920 and the Boring Mutual Telephone Company. He was also the secretary for the Boring Odd Fellows' sister fraternity, the Rebekahs. In

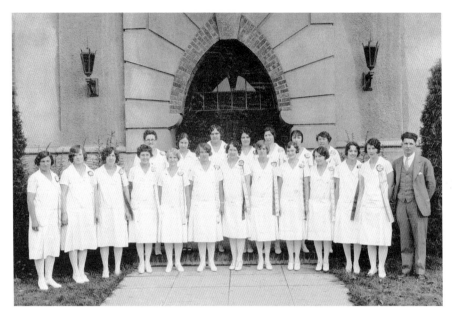

William Morand stands on the right side of this photograph of the Boring Rebekah degree team. *Courtesy of Sandy Historical Society.*

those days, a man could be a Rebekah—though it was uncommon—but a woman could not be an Odd Fellow. Now a woman can be an Odd Fellow if she wants or a Rebekah or even both.

Amy Morand was a member of the Rebekah lodge. She was the first noble grand of the local lodge. When the lodges were instituted, she was the assistant to the postmaster of Boring. She was the postmaster herself from 1903 to 1912; she was the second postmaster of Boring, taking over for Anthony Foster, who was the postmaster for just over six months. From 1928 to 1932, she became the postmaster again, making her the second and fourth postmaster of Boring. Amy was married to William Morand, but her maiden name was Roots. She was the daughter of James Roots, who was a member of the Odd Fellows lodge.

James Roots was the noble grand for the first year of the Odd Fellows lodge. He was an early Boring resident who built one of the first stores in Boring. James Roots was a prominent member of Clackamas County before he even made it to Boring. A biography of him was included in the *Illustrated History of the State of Oregon*, published in 1893. He was born in Chatham, England, in 1849. In 1853, his family immigrated to New York. In 1869, when he was only twenty years old, he traveled with his family

from Kansas to Oregon via wagon train. The family had three wagon trains and several mule teams to aid in the journey. The account of their journey stated that they were fully armed with rifles and revolvers in case of Native American attacks.

Along the way, they joined a larger group moving across the plains. While they were traveling with them, they were attacked by Native Americans. The fight was short, but one man from one of the other parties was taken by the Native Americans and never seen again. The attack was not the only trouble they came across in their journey. They got caught in a large storm, and by the time they made it to Oregon, their supplies had dwindled to almost nothing and they were running out of money.

Once in Oregon, James homesteaded on 160 acres of land. He farmed this land and also worked several years at the Clackamas Paper Company. At one point, Roots owned around 1,000 acres of land in Clackamas. When he passed in 1919, the Boring Odd Fellows conducted the ceremony. For more about what the ceremony would have been like, see "The Dynamite Mystery" chapter.

Wallace Telford was the treasurer; he was married to James Roots's daughter Myrtle and was now running James Roots's old store. He renamed it from J.W. Roots Merchandise to W.R. Telford's Merchandise. Later in life, Wallace would be a Clackamas County judge.

John Jonsrud was the left supporter of the vice grand. He helped rebuild the Kelso School when it burned down in 1905. His family is well known in the area. His father was a justice of the peace in Boring, and his brother Bert was the constable. In the nearby town of Sandy, there is Jonsrud Viewpoint on land that the family donated. It is a beautiful view where you can see the Sandy River, a valley and Mount Hood.

Now the name Odd Fellows might seem rather odd. You might be wondering, what is an odd fellow? Or why would someone call themselves odd? The legend is that they were called odd fellows because they were a group helping others, and at the time it was seen as odd to help people without looking for a return on the favor.

The other possible explanation is a little more complicated. Fraternal organizations have existed for centuries. You have the Masons, Woodsmen of the World, the Loyal Order of the Moose, Knights of Pythias, the Ancient Order of United Workmen and so many more. All these fraternal organizations were trade related: Masons were for people who worked in masonry; the Woodsmen of the World was for people who worked in lumber mills and such. All these fraternities acted like insurance companies

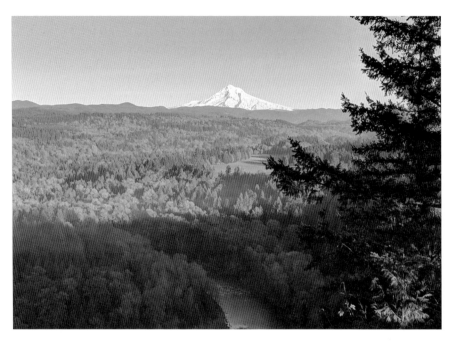

View of Mount Hood from Jonsrud Viewpoint. *Courtesy of Michael Wilson.*

for people. People paid in, and if they got sick, they would get financial aid. This worked well for the Woodsmen and the Masons. But what about people in other trades or people who worked "odd" jobs? At the time the Odd Fellows came to prominence, *odd* just meant diverse. It was not the insult that it became in the twentieth century.

It also might seem sinister that there was this group in Boring that wore strange costumes and had secret meetings and rituals. But it really was not as cryptic and scary as all that. The reason for the rituals and secret meetings was to keep people from taking advantage of the various secret societies because these fraternities gave out money to help their members. Some people would claim to be a member and hit up lodge after lodge to attempt to scam the lodge out of money. To fight this, the various fraternal groups created their "secret knowledge" that people could be tested on. Are you really a member? If I make this hand gesture, what hand gesture do you make? What happens in the second degree?

The Odd Fellows were a big part of the community in the earlier days of Boring. Besides this chapter, they are mentioned in three others.

At the time this book is published, the main meeting places in town are the fire station and the grange. But that has not always been the case. Boring did

not have a fire station until 1949, and when the town was trying to establish a fire department in 1947, the fraternity had its meetings at the Odd Fellows Hall. Before 1939, the grange did not have its own building either. So, members would use the Odd Fellows Hall for meetings and to put on dances.

The Boring School would even use the Odd Fellows Hall to have evening events because the school lacked electricity for lighting and the Odd Fellows Hall had it. School events included programs where the kids would perform skits and recitations and sing songs. The Boring Community Club would even have a fundraiser at the Odd Fellows Hall in 1928 to raise funds for the school to finally get electricity.

The Odd Fellows would have many of their own fundraisers over the years for the community. They sponsored the Boring Boys Scouts troop. In the *Clackamas County News*, they promoted a clam feed that the lodge was having. The newspaper said that "Boring Odd Fellow's lodge are already smacking their lips for the clam feed." The Rebekahs put on Halloween parties for the kids in the hall. The Rebekahs had a basket sale to raise money when the kids' uniforms burned in a fire. In 1941, the Odd Fellows, the Rebekahs, the Boring-Damascus Grange and the Boring Mothers Club teamed up to put on a large "hard times" party where they raised money to fight infantile paralysis.

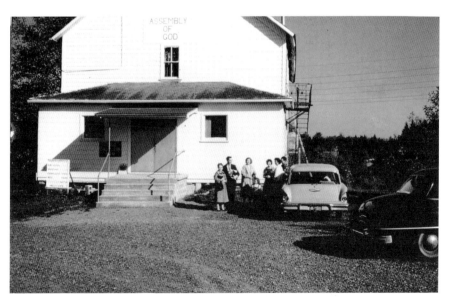

Assembly of God Church after a slight remodel and a new coat of paint. *Courtesy of Living Word Fellowship.*

The lodge surrendered its charter on December 18, 1957. By that time, most of the charter members had passed. Wallace Telford passed earlier that same year. James Roots died in 1919, Amy Morand in 1937 and John Jonsrud in 1940. William Morand was still alive but had moved to Portland years before and was in his mid-seventies in 1957.

Though the lodge may have closed in 1957, the building survived and became an Assembly of God Church until the 1990s. Unfortunately, the building burned down in 1996.

There is still a legacy from the Boring lodge. After Amy Morand died in 1937, her husband, William, started the Amy Morand Home Educational Fund with a $200 donation. The fund was originally used for the education of orphans at the Odd Fellows Home. William Morand eventually remarried, and when his second wife passed, he asked for the fund to be renamed Morand Education Home Fund. In 1956, it was renamed once again to the Morand Education Fund; they removed the word "home" since the Odd Fellows Home no longer housed orphans. The fund was eventually discontinued and forgotten about until 1978, when it was reinstated.

Today, the fund is known as the Morand Education Fund and is a scholarship that is awarded to eligible college students who have relatives in the order.

Chapter 4

DAVID WOLFE'S BAD DAY

David Wolfe was born in 1843 in Brushcreek Township, Ohio. In 1860, he was living in Jackson Township in Iowa. At nineteen years old, he became a Union soldier in the Civil War. He was mustered in Abingdon, Iowa, on August 9, 1862. He was mustered out in 1865 in Mobile, Alabama.

In 1888, he was living in Minneapolis, Minnesota. During his time in Minnesota, he was a reverend at a Methodist Episcopal church, where he would hold prayer meetings every Thursday. Minnesota is also where he would marry his wife, Rachel Rand. The couple would have four children together. Two were born in Minnesota. The oldest was named Guy Wolfe. The next two were fraternal twins, a boy and a girl. The boy was named Glen, and the girl was named Lem. A couple of years after the twins, they had one last child. She was the only one born in Oregon. Her name was Ethel, and she was born in Brownsville in 1893.

Once in Oregon, they must have felt like they finally found their home because Rachel and David Wolfe would spend the rest of their life as Oregonians. Before they made it to Boring, David was part of a church in Brownsville. In 1895, he moved to Springfield to replace the pastor who was moving to Amity. In the *Eugene City Guard*, they wrote about David taking over as reverend at the church. "He will be succeeded by Rev. David Wolfe, a man of age and experience, who will be well able to minister the spiritual needs of the people of his charge."

In 1904, David and his family finally made it to Boring, where David was a reverend at the Methodist Episcopal church. In Boring, they had enough

property to do some farming. In 1905, the reverend brought wheat stalks that were six feet, three inches tall to the *Oregon Daily Journal* to show them. David showed them the wheat and said, "It is one of the most powerful arguments I ever knew of in support of the claim of Oregon's great fertility."

By 1907, he had mostly retired from the church, but he would do the occasional services when called upon. His main source of employment at this time was as a rural mail delivery carrier. He worked for the Orient Post Office near the town of Boring. The Orient Post Office had been established only eleven years previously, but it was already on its way out.

In July 1908, the *Oregonian* ran an article about the change in rural delivery in the Boring-Orient area. It explained that the rural free delivery route at Orient was to be transferred to Boring effective August 1. The article theorized that this would be the end of the Orient Post Office because this would leave only a dozen homes to serve. They were correct in their theory. That post office closed in October of that year.

David Wolfe was not out of a job though. He was ordered to report for duty on August 1 at Boring. At this point in history, the Boring Post Office ran out of J.W. Roots Merchandise. This would not have been a surprise to David, because the Orient Post Office was also a general store. On the outside of the Orient Post Office, you could see advertisements for what they had for sale; there was a sign for Climax Plug Tobacco and a large poster for Heinz Baked Beans.

His new bosses were Amy Morand, the store owner's daughter, who was the postmistress, and her husband, William Morand, who was the assistant. This was not a bad situation for Wolfe. At Orient he made $720 a year, and at Boring he would make $900 a year. By 1911, he was earning $1,000 a year.

In 1913, the Boring Post Office moved from the general store to a new building built by William Morand. He took over as postmaster as well.

Sadness struck for David in August 1913 when his wife, Rachel, died while she was visiting one of their daughters in Philomath, Oregon. Rachel was only sixty at the time, while David had turned seventy earlier that year.

The unofficial slogan for the United States Post Office has always been "Neither snow nor rain nor heat nor gloom of night stays these couriers from the swift completion of their appointed rounds." Though that might not be an official slogan, many postal delivery workers have tried to live up to it. David was no different in that regard. The *Oregonian* referred to him as the oldest rural delivery person in Oregon. It also said that David was one of the most efficient and best men in the service despite his age.

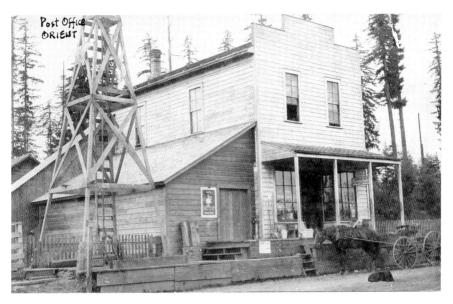

A horse and wagon stands out front of the Orient Post Office and general store waiting to do that day's deliveries. *Courtesy of Mark Moore.*

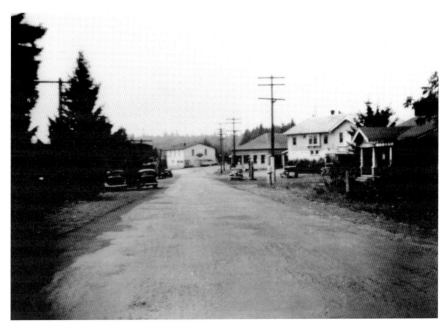

The brick building on the right side is the post office in the Morand building. To the right of it is the general store that the post office used to be in. *Courtesy of Living Word Fellowship.*

In an article titled "Veteran Braves Storm," the *Oregonian* tells the tale of David Wolfe only missing a few days of delivery during the snowstorm. Even though trees and telephone lines were being downed by the weather, he still made his routes most days. People along his route appreciated David for his hard work and how he always got their mail to them. Which is one of the reasons why there were so many people ready to help David Wolfe when he has his bad day.

Reverend David Wolfe's bad day was on a Thursday in September 1914. He was delivering mail on his route with his cart and horse. He had just dropped off the mail at Samuel Bacon's house. Sam was near David's age; he was around sixty-six years old. He was well known in the area. He once donated land for a school. His wife's name was Mary. Sam married her in 1875 when she was twelve years old and he was twenty-seven. They would have their first child three years later.

David was getting his horse moving again to go deliver mail to Charles Hunter. But David got the horse going too fast too quickly, and a strap broke on the horse's harness. The horse, knowing that it was close to being free, started kicking. In the process of clearing herself from the wagon, she broke both shafts. Once free, the horse ran off. Unknown at this time to David, she would run over three miles away until she was stopped by Elmer Bankus. Elmer would inform William Morand at the post office that he had the horse.

Sam Bacon is pictured on the far right sporting his favorite hat. *Courtesy of Sandy Historical Society.*

David was not defeated by this. The seventy-year-old man just picked up all his mail and started walking to his next house to continue delivering the mail on foot. Horse or no horse, he was making his route.

He was almost to James Speirs's place when Walker A. Proctor saw him walking. Walker had been a sawmill worker for much of his life but was now the president of the Clackamas County Bank. Years later, he would be the mayor of Sandy. Proctor was driving an automobile that David called his "Big Auto." Walker offered to take him on his route after they stopped at his place first. As they headed to Walker's home, David Wolfe was shocked at the speed of the auto and how it gave him little time to go through his mail and get it organized for delivery.

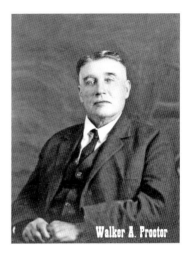

Business portrait of Walker A. Proctor. *Courtesy of Sandy Historical Society.*

The two made excellent time on his route and made it back to Boring at 1:55 p.m. William Morand was waiting for Wolfe when he got back, and he took him out to Elmer Bankus's place to get the horse with the buggy now attached to Morand's horse. They got the horse, and all was well until they were about one-fourth of a mile from Boring, when someone in an automobile went by and spooked David's horse. The horse jerked suddenly in response to the automobile and overturned the buggy. The horse started kicking again to break free, and another shaft was broken.

William and David walked their horses back to the post office. Elmer Van Fleet, the clerk at the Cottrell School, used the telephone and got Mrs. Shriner to fetch the buggy and bring it back to the post office.

Reverend David Wolfe was so thankful to his friends who helped him that day that he wrote to the *Gresham Outlook* to express his appreciation. He wrote a nice little piece that told the story and mentioned all the people who helped him that day. In the article, he also said that nobody got hurt and he was devoutly thankful for that. In reference to his route, he said, "I believe there are very few routes in all of Oregon that have a better class of people living on it than live on Route 1, Boring Oregon."

David Wolfe lived for another happy three years. The next year, he would find love again, this time with Emma Hartman, age sixty-two, who, like him, was recently widowed.

Wolfe did have one more horse incident. The *Oregonian* ran the article "Carrier Delivers Mail Despite Accident" in its May 11 issue in 1916. David Wolfe was out delivering the mail. He was near A.J. Ault's place when his wagon broke down. The article does not describe the accident, but it does explain that Wolfe had to climb out the back of the wrecked buggy to get out while his horse ran away with the two front wheels still attached to it.

Chapter 5

THE ONE-ARMED FIDDLER

Reuben Seaman Frank was a violinist and a luthier. Not only could he play the violin, but he also built them in his spare time. Both are challenging disciplines. But it is even more of an accomplishment when you find out that Reuben built and played violins without the aid of a right arm.

Reuben was born in 1866 in Mount Carroll, Illinois. In his fourteenth year, his family moved to Oregon. Once in Oregon, Reuben attended Pacific Academy, a Quaker seminary.

In 1891, Reuben first got into working with wood. He bought himself a steam-powered saw and got into business for himself. To promote his new venture, he ran ads in the local newspaper. He did not spend money on a huge ad. It took up around three-by-two inches of ad space on the third page of the paper next to the local interests section. But his ad stood out among the others because he used most of the ad space for the word "DON'T" in big capital letters. When you turned to that page, it was the first thing your eyes would focus on. Then in smaller print, he finished the rest of that sentence: "DON'T break your back sawing wood by hand. But get us to saw it with our New Steam Saw. 'Good work at living prices,' is our motto. Reuben S Frank."

The year 1897 was a life-changing one for Reuben Frank. It was the year that he married Sarah Hutchings, a woman he would spend the rest of his life with and the eventual mother of his four children. This was very much a bittersweet year for Reuben. In June of that year, he got his arm caught in a wood planer, which is a big machine with many giant gears and belts that

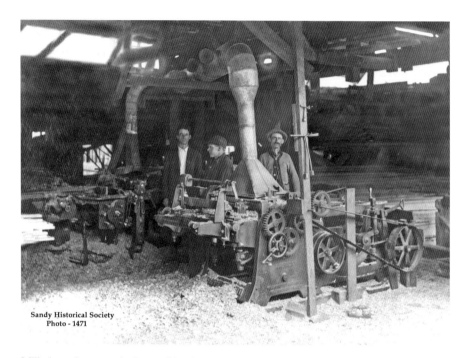

Sandy Historical Society
Photo - 1471

Mill planer in use at the Jonsrud brothers mill, circa 1914. Robert Jonsrud is on the left; Gilbert Jonsrud is on the right. *Courtesy of Sandy Historical Society.*

are used to take unfinished wood and cut it to a consistent thickness. Poor Reuben caught his arm in one of these, and his arm was crushed to the point that it had to be amputated. In October of that year, his father died of consumption.

After these setbacks, Reuben went through a series of different jobs. A few months after losing his arm, he was running a grocery store. In the 1900 census, he is listed as a night watchman. In the 1910 census, he was listed as a nurseryman, a career he would be in for the rest of his life—except for his brief venture into show business that is.

At the time of his show business career, Reuben and his family were living in Boring. Sarah Frank, his wife, became a mail carrier for the Boring Post Office, a job she held until 1919. They joined the Boring IOOF lodge. Reuben was a member of the Odd Fellows for forty years, and Sarah joined the Rebekah side.

Rueben was a musician at heart, and he did not want to give it up just because he had lost a limb. So, he created an attachment for his missing arm so that he could hold a bow and play violin once again.

In Washington State, there was a man named Bert Amend who had lost his right arm at a shake mill. Like Reuben, he was a musician as well. He played piano and guitar. Also like Reuben, he would not let the accident keep him from playing the instruments he loved. In 1905, Bert applied for a patent for a device he invented that would help a person missing a limb to be able to play chords on the piano. His patent was granted in 1906.

How Amend and Reuben found each other is unknown. But in 1910, they formed the Amend-Frank One-Armed String Orchestra. Reuben was not only the violinist in the group. He was also the musical director. In this new career, Reuben would be billed as the One-Armed Fiddler.

The two gathered five other men for their band. Jack Wedel played trombone, L. Stein played the coronet, Lester Cox was the drummer, William Tienken played the mandolin and Arthur Hanson played both the violin and cello. It was said that each of these men had lost their arms in sawmills and lumberyards in Oregon and Washington. Almost all of them were missing their right arm. The drummer, Lester Cox, was the only one missing his left.

The band was formed in September 1910, and they practiced twice a week, building toward their big initial performance at the Lents Grange Hall

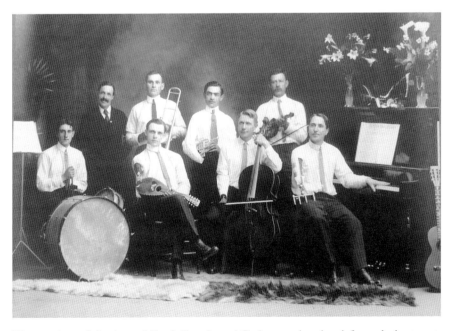

The members of the Amend-Frank One-Armed Orchestra take a break from playing to get their photo taken. *Courtesy of Sandy Historical Society.*

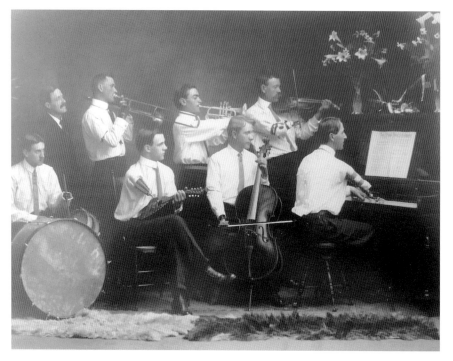

Reuben Frank plays his violin standing next to Bert Amend, who is playing the piano.
Courtesy of Sandy Historical Society.

in February 1911 that their manager Alfred Spreadborough had booked for them. The band was a local hit from the start. At that gig, they were met with applause after every song and played many encores.

Another early gig of theirs was a few months later in May at the opening of the North Albina Library. It did not go exactly as planned. The program was going well until the lights went out in the middle of their set. Being professionals, they lived up to that old show business saying, "The show must go on." They kept playing through the darkness as candles were located to light the room, and they finished out their set to candlelight. After their set, a few people gave speeches about the new library. Dr. Elliot, Reverend Snider, Professor Jenkins and Mr. Osborn all took a moment in their speeches to say how much they enjoyed the performance by the band.

Eventually, the band would move on to bigger venues. Reuben Frank's obituary mentions that they played on the Orpheum circuit. The Orpheum was a chain of vaudeville-like theaters. During this time, they had theaters in Oregon, Oklahoma, California, Massachusetts, Arizona and even one in New York City.

In the last few years of the group, it went from an orchestra to a trio. When it headlined at the Star Theater in Medford in 1914, the group was billed as "Amend, Frank and Shirley, the One-Armed Trio." It was advertised as "a great vaudeville novelty act."

After his musical career ended, Reuben went back to the nursery business. He still played violin, and his grandchildren have memories of watching him build violins in the basement of their home. After he passed at the age of eighty-three, the violins went to his wife, Sarah. Then when she passed, they went to their daughter Violet. After Violet passed, Maynard Cannon, her husband, had possession of them. Once he passed, the violins were donated to a local school's music department. No one in the family can recall which school.

There was one violin left—Reuben's personal violin. In 2019, it was donated to the Sandy Historical Society.

PART II

BORING CRIMES

Chapter 6

DEPUTY SHOOTS TWO BOYS

Morris Wheeler had many professions during his life, but at the time of the incident, he was a Clackamas County deputy sheriff. Wheeler was forty-eight years old at the time of this story. He was born in 1864 in Oregon. In the 1880s, he married Sarah Fidela Waybill, and they had one son named William.

In 1900, Morris was the school director at the Orient School. But when the census taker came around, he told them that he was a farmer. Which he was; he did have a farm. Regardless of his work outside his farm, he would always tell the census taker that he was a farmer. He did this again in 1910 even though he was a county clerk at the time and again in 1920 when he was a road district supervisor. Wheeler was never one to have just one job. In 1918, one of his jobs was a patrolman. Outside of his many jobs, he was also a member of the Orient Grange and the Boring Odd Fellows.

The incident happened in 1913. Morris Wheeler was a deputy sheriff at the time he shot the two boys. He was not on duty at the time of the incident.

Kenneth Specht was the younger of the two boys. He was seventeen at the time of the incident. His full name was Ernest Kenneth Specht, named after his father, Ernest G. Specht. Kenneth was a well-beloved boy in the town of St. Helens. When he was fourteen years old, he got his name in the *Oregon Mist* for being in the advanced department at his school and for being in the honor roll. By 1913, the family had moved to Portland and was living on Couch Street. In Portland, Kenneth got himself a job at a meat market on East Burnside Street.

In Portland, Kenneth would make friends with an older boy named Donald Cooper. Little is known about Donald Cooper because there are

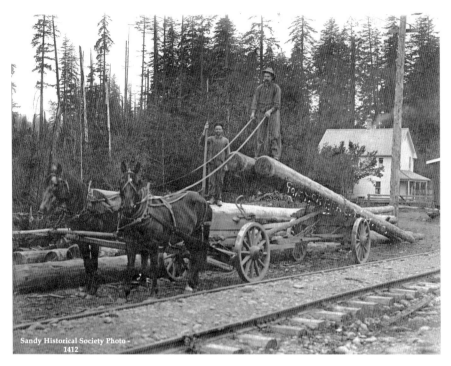

Sandy Historical Society Photo - 1412

Morris Wheeler doing one of his many jobs. Here he is standing on top of two logs that he is moving with a team of horses. *Courtesy of Sandy Historical Society.*

no other articles about him and there is no Donald Cooper in the census records living in Portland who was born about 1893 on the 1900, 1910 or 1920 census.

In the various articles written about this incident, they refer to Donald and Kenneth as boys, even though Kenneth was seventeen and Donald was twenty at the time.

Donald and Kenneth had been chums for many months. According to most accounts, Donald Cooper was a bad influence on the younger Kenneth. He was the one who convinced Kenneth to take the horse and buggy from the meat market where Kenneth worked. Donald thought it would be a good idea to steal the horse and buggy to use as transportation to get to eastern Oregon to get jobs, even though Kenneth was happy with the job he had. Donald was also the one who brought a gun on their journey.

The two young boys took the horse and buggy from the meat market on Sunday afternoon. Their goal was to make it to eastern Oregon, but they only made it as far as Boring. By the time they made it there, it was past midnight, and Kenneth's mother was already worried and searching for

him. At around one o'clock in the morning, the boys stopped at a farm to set up camp and try to find some hay for their stolen horse.

The two found a barn, but unbeknownst to them, it was the barn of Deputy Sheriff Morris Wheeler. They entered the barn to look for hay. The boys must have been clumsy or Wheeler had great hearing because Wheeler was awakened by the noise they were making in his barn.

Wheeler decided to investigate the sound. He brought his shotgun loaded with birdshot for the investigation. Once inside the barn, he discovered the two searching around. His first thought was that they were horse thieves, which they were; they had stolen a horse. But they were not trying to steal his horse. Wheeler yelled at the boys to raise their hands to the sky.

This is where Donald, the older boy, escalated the situation and made it so much worse for the two. Kenneth was quick to throw his hands up in the air, but Donald only put one arm in the air, and it was holding a pistol that he was pointing right at Wheeler.

Mr. Wheeler responded quickly to the sudden threat and pulled the trigger of his shotgun, sending birdshot in their direction. Donald was hit in the breast. Kenneth was hit twice in his left hand.

Kenneth and Donald were quick to surrender after being shot. Wheeler took the two of them to his house and phoned for a physician from Gresham. Two hours later, Dr. Hubert Hughes was at Wheeler's farm to look at the boys.

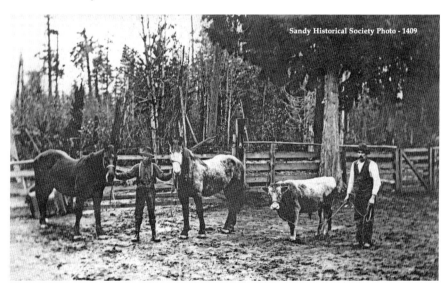

Morris Wheeler and his brother on his farm. *Courtesy of Sandy Historical Society.*

Dr. Hubert Hughes was born in Missouri in 1882 but grew up in Montana. He graduated from the University of Montana and Rush Medical College. He came to the Portland area to do his internship at the Good Samaritan Hospital but ended up liking the area and took up residence in Gresham in 1912. He would practice medicine in the Gresham area for forty years. He was even the mayor of Gresham for sixteen years.

The doctor dressed the boys' wounds. Donald was the more seriously injured of the two, and he was left at Wheeler's house to recover. Kenneth's mother came to the farm for Kenneth, and they made their way to Oregon City to find out how much trouble he was in.

In the morning, Wheeler took Donald on the early train out of Boring to Portland. From there, they caught the train to Oregon City to turn the boy over to Sheriff Mass. Morris also surrendered himself for questioning, but he was not arrested. It is unknown what kind of punishment, if any, the boys received. The only mention of legal trouble was in the *Morning Enterprise*. It said that they would be prosecuted in Multnomah County for taking the horse and buggy without obtaining permission from the owner.

The *Oregon Mist*, the paper from the town Kenneth used to live in when he was younger, ran an article that painted the story in a different light. The article made it seem like it was all just a misunderstanding. The headline was "Kenneth Specht Shot, Former St. Helens Boy Taken for Robber Received Wound." It goes on to state that Kenneth was shot in the hand while on a trip to eastern Oregon. No mention was made of the fact that they were making the trip on a stolen horse and buggy. The article underplayed their fault in the barn incident. It said that the boys entered the barn for some feed for their horse and were caught by the owner, who must have thought them to be highwaymen, and he began to shoot since one of the boys did not raise his hands. It fails to mention that the boy who did not raise his hands pulled a gun and pointed it at the owner of the barn.

It is unknown what happened to Donald Cooper. But Wheeler and Kenneth Specht moved on with their lives. Specht joined the war effort in 1917. He survived the war and got married in 1924. Wheeler became a patrolman a few years later and then became a road district supervisor. He was seventy-four years old when he passed in 1939.

Chapter 7

THE MOONSHINERS

There are many choices nowadays if one wants to get a drink in Boring. There is the Boring Bar that is in the old Morand brick building that was built in 1913 to serve as the post office and drugstore. There is also the Timber Tavern located across the street. Once upon a time, it was called Harvey's, and it had a little trouble in the late '50s for illegal gambling. The list goes on. There is the lounge at Red Apple, the lounge at Nuts on Sports, Backroads Pub and Grub and, at the time of this writing, the newly opened Chester's. Chester's is in the old Alpenhaus Swiss Deli building in the old Heidi's complex. But most people seem to remember it as the old Funny Farm building.

This town has not always had that many bars. At one time, there was only the one. Then, for a period, there were no bars in town.

The earliest bar in Boring's history was T.M. Allison's Saloon, run by T.M. Allison. But to regulars, he went by the name Jim. It was a big tall building with a flat-paneled front, and it was located right behind the first train depot of Boring. He made his building obvious to the millworkers and any other visitors to Boring coming off the train that it was a place to get alcohol. If you were in the mood for a drink and new to town, it was not that hard to figure out where the bar was because in giant letters written on the front of the building was "Weinhard's Beer." People heading through Boring on the train would often stop in Boring for a drink at T.M.'s saloon. His patrons who came off the train referred to T.M. Allison's Saloon as the "first chance" for booze after leaving Multnomah County and the "last chance" on the way back.

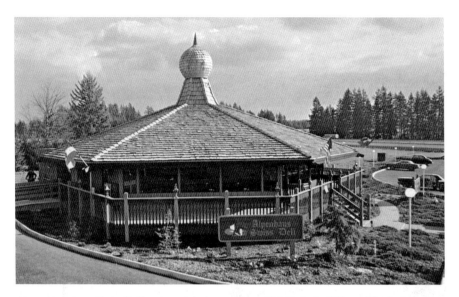

Above: Alpenhaus Swiss Deli postcard that was sold at Heidi's Swiss Village. The building is now occupied by Chester's Pub. The ball on top is no longer there. It was destroyed when it was struck by lightning. *Courtesy of Micah Ohara.*

Opposite: In the center of this photo is T.M. Allison's Saloon. "Weinhard's Beer" is painted in giant letters on the front. *Courtesy of Sandy Historical Society.*

The saloon was established in 1904, just a year after Boring was officially platted. The town had to petition for Allison to get a liquor license. There were nearly thirty names on the petition, one of them being future deputy sheriff Morris Wheeler. This petition was printed in the *Oregon City Courier*. It read: "To the county Court of County of Clackamas, State of Oregon. We, The undersigned, legal voters of Boring, in the town of Boring, in Clackamas County, Oregon, most respectfully petit on your honorable body to grant a license to T.M. Allison to sell spirituous, malt or vinous liquors at Boring, Oregon."

The liquor license was for one year. He received it, but the next year he forgot to renew. A few months after it expired, he was arrested for not renewing his license. He pleaded guilty and paid a $200 fine. This is possibly the first liquor-related crime in Boring, of which there would be many once Prohibition went into effect and the moonshiners came.

T.M. Allison's Saloon would not last too many years. In 1907, a law passed banning liquor sales on Sunday. This must have hurt Allison's business, but it survived with one less day of revenue a week. The saloon stayed open until the following year, when liquor was outright banned in Clackamas County,

Sandy Historical
Society Photo -
1538

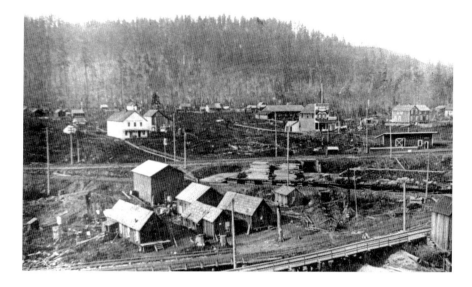

making Boring a dry town. A dry town or county is a place where alcoholic beverages are prohibited from being sold. T.M. Allison abandoned his saloon soon after, and it burned down the following year.

Boring would remain a dry town until Prohibition happened. Legally, it was still a dry town, but with alcohol now becoming illegal, this brought liquor back to Boring. There were a few moonshiners who thought Boring, Oregon, would be the perfect place to run an illegal still.

In the first year alone, there were many different groups that would be caught in Boring with liquor-making equipment. There were probably even more stills during this time; not every moonshiner is caught. One rumor was that the sheriff kept checking on one moonshiner's property, but every time the sheriff would come out, he would get tipped off and would disassemble his still and hide it around his farm. According to legend, that person never did get caught.

Another moonshine operation run by a couple men from Portland was not so lucky. Their operation was on a farm that they rented from Emma Saylor. The farm was in the Sunshine Valley area of Boring near the Haley train station. They were unlucky because they, too, tried taking their still apart and hid it in various spots on the farm that they rented. Sheriff Wilson was the lead in the bust. Sheriff Wilson was around fifty-five years old and had been sheriff for five. Deputies Long and Hughes and a United States

revenue officer were there for the raid as well. They were quickly able to find all the pieces of the twenty-gallon-capacity still. They even found a small amount of liquor on the property.

Before the still was taken apart, it had been set up in a small shack by a nearby creek. To their detriment, moonshine operations always needed access to a lot of water. The law and the revenue agents knew this and would search near creeks first whenever they heard rumors of a still. In the Sunshine Valley area, it was easy to find an old shack to use. The area once had a train that went into it for logging, but after a few years, the logging was done. The train tracks were pulled out, and what was left was a bunch of decaying bridges and abandoned homes and shacks where the loggers used to live.

One still that did well at hiding its operation was the still run on the farm of fifty-five-year-old Minnesota-born but longtime Oregon resident Stillman Andrews. Yes, this man accused of running a still was really named Stillman. The *Oregonian* newspaper joked, "The name may have put the booze hounds on the scent." The name did not put them on the scent. But the scent of the still would help the law find the still.

Stillman lived on a farm on the right fork of Bear Creek near the Cottrell Station on the outskirts of Boring. He ran a slaughterhouse and sold meat to farmers and other residents in the area. He had his own store called Andrew's Meat Market. When he was younger and his kids were still in school, he worked as a clerk at their school in Cottrell.

His neighbors were the ones who tipped off the authorities that Stillman; his son Melvin, age twenty-three; and his even younger adopted son Lester Halmadge, age twenty, were known to sell liquor in town. The neighbors also told tales of frequent visitors to the farm by groups in automobiles. Andrews's property had been searched twice before without luck. But the third time was the charm. The headline in the *Oregon Journal* read "Noses Detect Liquor Odor; Still Raided."

Around 7:30 p.m., federal Prohibition agents Edward Wolfe, M.T. Burnett and Deputy Sheriff M.M. Squires were all out searching near Stillman's farm for the still when they got a whiff in the air of sour mash. It was not dark yet, but if they were going to find the still that night, they would need to move fast. They followed their nose to a spot where they thought the stench of the mash was the strongest, but they still could not seem to find the still. They knew they were close, so they kept searching until one of them found the camouflaged tent that covered the dugout where the still was located. The tent was camouflaged well with fir boughs, which made it easy to miss.

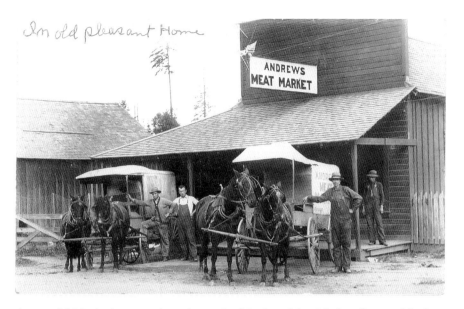

A young Melvin Andrews stands on the porch of Andrews Meat Market. *Courtesy of Sandy Historical Society.*

The still might have been hard for them to locate. But it was not a small still; it was large, with the capacity of producing 150 gallons. Near the still they found one 50-gallon barrel of corn whiskey and six barrels of corn mash.

When they questioned Andrews, he denied any knowledge of the still. But there was plenty of evidence that this was his operation. First off, it was on his property. Second, there was a trail from the still to his slaughterhouse, and third, in the slaughterhouse they found a quart bottle of the same whiskey that was found in the barrel. In another barn on the property, they discovered a dozen packages of hops. They found caramel dye for coloring the whiskey, and they also found a blow torch and a large piece of solder that they believed he used for assembling and repairing the still.

All three were arrested. According to the *Oregon Daily Journal*, members of the sheriff's office believed that Stillman was once associated with Nettie Connett, who had recently been convicted of violating the Prohibition law.

Nettie Connett was infamous in the area, and not just for making moonshine. She was an avid hunter, and some called her a showoff because she would always bring her recent catch to town to show everyone. Be it a cougar, a bear or deer, she always tried to be the first one to town to show off her catch when the season opened. Some people were cynical and thought that she went out a day or two early to shoot the animal she was

after to make sure she was the first one back to town with their catch. She was known to wear men's clothing. This is basically a nonissue today, but in early twentieth-century America, it was strange for a woman to be seen wearing a man's jacket and jeans. She did many things considered manly. Some of the other things she did that were not seen as ladylike were chewing tobacco, cursing and drinking. An interesting similarity between her still and Stillman's is that they were both found in dugout holes.

A few days after their arrest, Andrews was released on bond for $1,000, and his son and stepson were released for a bail of $500 each.

Several months later, they went on trial in front of United States commissioner Fred Drake and a federal grand jury. Stillman again stated that he had no knowledge of the still operating on his property. Then Stillman accused the raiding officers of being drunk when they raided his farm. The government produced six witnesses to refute the charges that the agents were drunk. After a two-day trial, the jury was out for only an hour before coming back and finding the defendants not guilty.

The next moonshiners to be caught would not get off so easily. Their names were Nick Fakaras, Chronis Grizakis and Kosmos Tsitillos. Their still, located in a small shed, was discovered by Sheriff William Wilson and Deputy Henry Hughes. Once they found the still, they busted it up and destroyed over one hundred gallons of the rum that the two men had been making from molasses. There was another sixty gallons of mash ready to be made into more alcohol found on the property as well.

Before destroying their equipment, Sheriff Wilson did note that this was one of the best stills they had seen so far. It had a complex filtering process. It consisted of two large vats made of wood, and each was seven feet tall and two feet in diameter. The liquor was strained through these filters that had alternate layers of charcoal, sand and blankets. The *Oregon City Enterprise* would describe the complexity of their operations with a little joke about the suspects' names. It went like this: "Nick Fakaras, Chronis Grizakis and K. Tsitillos, Greeks, with equipment and apparatus for making moonshine as elaborate and as complicated as their several names."

There was no claiming that they did not know the still was on their property in this case because this raid happened after a week of surveillance by Wilson and Hughes and when they raided the farm, they caught them red-handed in the distilling process.

It was a good thing that they were able to apprehend them quickly, as this operation did have the potential to turn violent. Weapons including stilettos and sawed-off shotguns were found near the still.

Sandy Historical Society Photo - 1648

Nettie Connett with a big smile, showing off her bobcat. *Courtesy of Sandy Historical Society.*

They had been renting the place for a while, but it was believed that they had not sold any moonshine yet. The moonshiners stated their intention was to turn out 150 gallons of rum to sell to Portlanders in large quantities for Christmas consumption.

Little is known about Chronis Grizakis; he is mentioned in the first two articles about this still and then is never mentioned again.

Nick Fakaras and Kosmos Tsitillos were initially sentenced to hard labor at Kelly Butte at the county rock pile. It was later reported by R.P. Bonham, head of the United States immigration service in Portland, that the two had a long history of violations and were considered undesirables. In fact, before this ordeal, revenue agents had already been looking for Nick for several months.

Nick Fakaras was fifty-five years old and had spent the last seventeen years in American but never became a citizen. He was of Greek descent but was a Canadian citizen. He was supposed to be deported back to Canada. But Canada refused because before the moonshiners started making moonshine in America, they went up to Canada to make it and smuggle it over the border. They got in trouble in Canada and moved back down to the States, where they set up another still near Deer Island. They of course got caught again, paid a bond and got released and then moved on to Boring to set up a still. Since Canada refused to take Fakaras, he was deported to Greece. Kosmos Tsitillos was also deported to Greece.

The largest moonshine operation in Boring's history was the still run by two Austrians who claimed to be cousins both named Boze Boze Yuginivic. The headline in the *Oregonian* was "Big Liquor Haul Made." The cousins shared a name but not responsibilities. One was said to be the manager, and the other one was an employee. This still was another bust by Sheriff Wilson. With him was Deputy Henry Hughes and two Prohibition agents, Flanders and Kerfoot.

This still was hidden well in the basement of an outbuilding. The *Oregonian* wrote that it was located under an outhouse. The operation was running on a five-acre piece of property that the Yuginivics rented. On the property, Sheriff Wilson and crew found 75 gallons of moonshine whiskey. They also found corn, hops and other liquor-making materials. This was a big-time operation. The most impressive part of this bust and what made this the biggest bust at that time was the 1,700 gallons of mash found hidden in underground pipes and vats. This was not a quickly put-together still to make a fast buck. This was a professional operation put together right to make big money. They found professional testing equipment, and the heating stove

was said to be a large, imported twin burner that could heat both of the stills that were found at the same time. This equipment could produce 75 gallons of whiskey a day.

With this being such a large bust, newspapers all over Oregon reported on it. It of course made it in the main Oregon newspaper, the *Oregonian*. But it was also published in the Beaverton and Salem newspapers, which are over thirty miles away. It was published in the *Monmouth Herald*, which is 75 miles away. The story even reached all the way to Vale and Nyssa, bordering towns to Idaho, nearly four hundred miles away from Boring. This bust was big news.

The two men claimed to have not been in operation long. But Sheriff Wilson and the others found thirty-six empty bags of sugar, six cans of oil and eleven empty kerosene cases.

Boze and his cousin Boze were both arrested at the time of the bust on April 22, 1920. They would sit in jail until April 30 when they would have their hearing. They went in front of United States commissioner Fred Drake, pleaded guilty and paid a $200 fine each. They were bound over to the federal grand jury and had to pay $500 bail each. They both refused to name any higher-ups connected with the moonshine operation.

Austin Flegel Jr., an assistant United States attorney, was at the hearing. He was an attorney at the time, but his sights were on being a politician. Six years earlier, he had lost a five-way race to represent Oregon's Third Congressional District in the United States House of Representatives. He received 32 percent of the vote. Flegel was president of Willamette Iron and Steele for several years. That company built naval ships during World War II. His political goal would not be realized fully until he became a part of the Oregon Senate in 1949. Then in 1953, Flegel was appointed director of the United States Economic Mission to Thailand, which leads to what he is probably most known for. While in Thailand, he purchased an elephant that he donated to the Oregon Zoo named Rosy. The arrival of Rosy was celebrated by a parade. About 100,000 people showed up for the parade to see Rosy on her float.

After the hearing, Austin had a lot to say to the press about the moonshiners. He told the press that at least 75 percent of the moonshiner cases that had come to his office in the last few months had connections to Austrians and that in almost every case, bail had been paid by another Austrian. Flegel went on to describe that the person acts as a "fixer" paying all fines, bails and charges. Flegel then warned that others might find themselves caught up in the web of evidence against the Austrian moonshine ring and that additional developments might be expected at any time.

After their fines were paid and things had blown over for the two cousins, they moved on to Newberg, where their boss had set them up with another operation. They got the same deal as before. The cousin who was the manager was making $300 a month. That was good money at that time. In 1920, you could buy a brand-new Ford Model T for only $395. Part of their deal as well was that their boss paid all legal fees, including counsel, in the case that they got caught.

This operation, just like the operation in Boring, got raided, but this time the moonshiners saw the officers coming. They were in an old shack that gave them a good view of the surrounding area. Once they saw the officers, they took off with the still operating. This was another big still. The *Oregonian* referred to it as "mammoth." It was said to be able to produce one hundred gallons a day. At the site, they found all the usual items: corn, hops, cases of coal, one hundred gallons of whisky and one thousand gallons of mash. Instead of putting the still right next to a creek, as most moonshiners did, they had a water pump to move the water from a nearby creek to the still.

This still was located roughly forty miles from Boring and in a different county, which is why it was not Sheriff Wilson busting the still this time. It was Prohibition agent Edward Wolfe, federal inspector C.R. Stipe and deputy collector Asa Smith. Wolfe was familiar with Boring, as he was involved in the case that brought in Stillman Andrews and his kin. But he was not there when they busted the still run by the two Boze Yuginivics. If he had been, he would have recognized them when they were picked up later and would not have believed them when they gave their names this time as Bob Uger and Mike Basich. It would be a while before anyone made that connection. Just like in Boring, they claimed that they did not own the still and were just employees. Just like the last time they were busted, they refused to give the name of the person they were working for.

This still only had the chance to produce four hundred to five hundred gallons of moonshine before they were caught. The officers took enough samples and equipment for evidence and then set the still ablaze. Newberg residents claimed that the raiding officers Edward Wolfe and Smith became intoxicated on the captured moonshine. This rumor might not carry much weight if not for the fact that Wolfe was one of the officers accused of being drunk when Stillman Andrews was busted in Boring. Wolfe said that he had not touched the liquor except to taste the two different containers to assure himself that the contents were in fact moonshine.

A month before this, a different Basich got himself in trouble when he was caught transporting moonshine to the Oak Hotel. This could have been

what got assistant U.S. attorney Flegel on his scent. Flegel believed that this Basich, first name John, was the ringleader of the Austrian moonshine ring. In the *Oregon Journal*, he was quoted as saying, "The real man in the Newberg still case has been found."

Just a few months after the Newberg bust, John Basich was arrested on a secret federal grand jury indictment. Austin Flegel said that he got information about his involvement from other bootleggers and that John had been the one to pay the fines for the two who were busted working the Newberg and Boring stills.

The trial would begin in January, six months after the bust and two months after the arrest of John Basich. The trial was now focused on John Basich, but Mike Basich would be the one to make the news on the first day of the trial.

After the court had been adjourned for the day, he went after Mike Mikolish, who was one of the state's witnesses. He was upset that this man would appear against his friend John. Though Mike and John had the same last name, they claimed that they were not related. But Mike Basich was also one of the men who claimed his name was Boze Yuginivic the previous year, so who knows. Witnesses said that Mike Basich threatened Mikolish by yelling, "I got a good notion to throw you from this here window! I tell you now Mikolish, for your own good, if you testify against John, this state will be too hot to hold you."

Assistant federal attorney Austin Flegel Jr. was quick to get to Mike Mikolish and start to comfort and calm him down; he did not want to lose his witness. Then Austin made sure that Mike Basich was arrested with the charge of attempting to intimidate a witness.

If Mike Basich was mad at Mike Mikolish for daring to testify against John Basich, he must have been furious when his partner Bob Uger, aka the other Boze Yuginivic, testified against John. Bob told the court that he had run a still for John Basich in Boring for $300 a month plus expenses, and after it was busted, John paid his fines and built the Newberg still for him to run with the same deal as before.

During the trial, they brought up the similarities between the twenty-four pints of whiskey that John Basich had when he was busted at the Oak Hotel and the whiskey from the Newberg bust. They showed that the whiskey bottles from the hotel bust and the ones found at the Newberg operation were the same shape and size. They also believed that the whiskey in the bottles from the hotel was made with the same process as the whiskey found at the Newberg operation. The defense objected to this, as this was a

different crime than the moonshine operation itself. The court ruled that it was relevant if proved to be connected to the moonshine operation.

At the close of the trial, the following instructions were given.

> *Now, there was testimony introduced in this case that in June of 1920 the defendant was apprehended with a suitcase containing liquor. He is not on trial for that offense. That evidence is to be considered by you only as bearing upon the issues tendered by the indictment in this case. It was admitted for no other purpose, and is not to be considered by the jury for any other purpose; that is unless you believe, beyond a reasonable doubt that the defendant kept and maintained a nuisance, as I have defined that term to you.*

John Basich was found guilty by the jury for manufacturing liquor, transporting liquor and possession of liquor. He was fined $500 and sentenced to a year imprisonment.

His lawyer, Barnett Goldstein, tried to get a reverse of judgment because they had brought up the Oak Hotel incident, which he argued was an unrelated crime. The reversal was brought in front of William Gilbert and William Hunt, who were circuit judges, and Frank Rudkin, who was the district judge. They stated, "It seems manifest to us that testimony tending to show the possession by the defendant of similar liquor in similar containers while the still was in operation was relevant to the issue before the jury, and its admission as limited by the court was not error. The Judgment is therefore affirmed."

John Basich, the leader of the moonshine operation, went to jail.

Chapter 8

THE WILD WEST GANG

Glenda Boring, wife of Bob Boring, the great-grandson of William Boring, was once interviewed about the town of Boring. When she was interviewed, she talked about the good things in the town, but she also talked about the things that Boring does not have. One of those things that she mentioned was that the town has no gangs. This is true; Boring does not have any gangs, but for a brief period, the town of Boring did have a gang. The *Oregon City Courier* in 1919 ran an article about the gang with the headline "'Wild West' Club Is Short Lived."

It was 1919 when the bandits in the Wild West Gang committed their "reign of terror," as the *Oregon City Courier* referred to it. That is a bit of an overstatement; newspapers in that era loved to use the words *terror* and *terrorized* for mundane situations. The so-called reign of terror is most likely an overstatement because the gang operated for only a couple months before getting caught and was not mentioned even once in the papers before it was discovered.

This gang is not like a modern gang. There are no drive-by shootings; nobody was "jumped in." There were not even any turf wars, which was a common thing with the gangs in the bigger cities at that time. It was known as a gang because its members committed crimes as a group but mostly because they called themselves the Wild West Gang. They came up with that name because they loved the Wild West stories that were popular at the time.

The crimes they committed were not terrorizing because there was no confrontation in them. They stole in secret and even referred to their missions as "going on a sneak." They would pick a local business or building

and break into it at night when no one was around. They broke into the post office, the school, the train depot and W.R. Telford's Merchandise. They did not steal much money. Mostly the gang stole items that they kept in their hideout in the woods about a mile out of town. This hideout and what it contained would eventually lead to their capture.

Sheriff Wilson was a busy man; he was mentioned in two different articles on the front page of the April 11, 1919 edition of the *Oregon City Enterprise*. The first is about him catching a large moonshiner operation a few miles outside Boring. The second article is about him catching the Wild West Gang. Their crimes were not even known at this point. The gang was just unlucky. Sheriff Wilson was probably out in those woods looking for moonshine operations when he stumbled across their hideout.

When Sheriff Wilson entered this homemade hideout, he found many items that would turn out to be stolen. A partial list of items found included tobacco, pipes, cards, rifles, auto tubes, purses and some money. The *Oregon City Courier* said there were too many items found to list them all. The items alone would not be enough to take down the gang except that the sheriff also found their diary. The diary had their list of bylaws, their member roster and the crimes they had committed.

Their bylaws were "No fighting, no lying; obey the captain when on a sneak; tell no one about the clubhouse, unless given permission by the

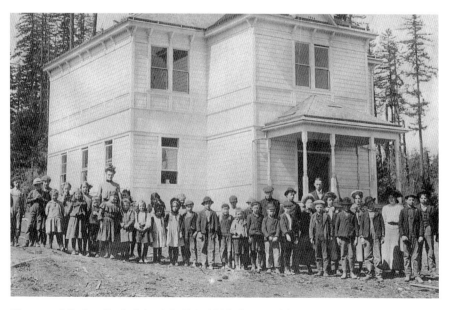

The second Boring Grade School, built in 1904. *Courtesy of Sandy Historical Society.*

captain. Captain will hold office for one month, then a new captain will be elected by the members."

With this information, it did not take the sheriff long at all to pick up the gang members. There were only three, and two of them were brothers.

So, who were the members of the Wild West Gang? The brothers were Vernon and Lural Wilson (no relation to Sheriff Wilson). The other member was Walter Wallomgett.

Lural and Walter were ranked as privates in the gang. Vernon was two years older than the younger and was ranked as captain. Vernon "The Captain" Wilson was fourteen years old, and the two privates were twelve. Vernon and Lural were the sons of Frank and Gertrude Wilson, recent Boring residents. Frank was born in Pennsylvania. Gertrude was born in South Dakota. On the previous census records, they were living in Reedville, Oregon. Frank was a carpenter, working on houses, and Gertrude worked on a dairy farm.

The boys' young ages did not stop them from having to go to court for their crimes. The two younger boys got a good talking to by District Deputy Joseph Dean Butler and were released to their parents. Joseph Butler was around thirty-six at this time and was described as a prominent young attorney. He graduated from a school in Monmouth, near where he grew up, and then attended the University of Oregon, where he studied law. He had recently been appointed as the district deputy. The previous district deputy had resigned to take a position at Ellison & White. Deputy Butler did not take it as easy on the captain of the gang. Vernon Wilson, being the oldest and the captain, took the brunt of the sentencing and was sent to the Oregon State Reform School.

The reform school was an older building, built in the early 1890s. It contained many amenities, a gymnasium, a hospital, electric lights, running water and even a library. The boys would still take classes and would be taught trades like carpentry and painting. But the conditioners were not great. Around this time, there was a state commission report that said that the hygiene was bad at the school, that children shared combs and only got a bath once a week. If a boy got in too much trouble at the reform school, he would be put on a diet of water and bread.

Luckily for Vernon, he did not spend too much time at the reform school. The next year, by the time the census taker came around, Vernon was back living with his parents and his brother Lural in their new home in Portland.

THE DYNAMITE MYSTERY

M arch 1928 would be a month that changed the lives of those in the Jones family forever. The family was not well-to-do, but they were getting there. They had an automobile, and they had just bought a home from Albert Johnston, who had moved to a bigger home next door. The father, Robert Jones, was a hardworking man who provided for his family. He was born in 1883 in Owyhee, Idaho. Before he moved to Oregon, he lived in Washington State.

In 1907, he married a woman named Eva Bailey. Together they had one child, Earl Jones. Eva Bailey sadly passed away two days after giving birth to Earl. Two years later, Robert found love once again and married Inace Roe. Inace was a North Dakota native who moved to Oregon at the beginning of the twentieth century.

At the time of the tragedy, Robert and Inace had been married for seventeen years. Aside from Earl, they had three children together. Richard was the firstborn of their marriage. He was now seventeen years old. Three years after Richard was born, they were blessed with a daughter whom they named Ethel, possibly after the middle name of Inace's mother, Laura Ethelda Roe. Their last child to be born was young Harold, who was only ten years old at the time of the incident.

Earl was now nineteen years old, and he had already gotten into a bit of trouble. A while back, he had disappeared for a few months with the family's car and went to California. But he never said why he left or what he was doing while he was gone. This made Robert quite nervous, and when Earl

came back, Robert was more controlling of him. Sometimes Robert and Earl would have arguments over this. But in the end, Earl would obey his father. Their most recent fight was over Robert not allowing Earl to go to a basketball game in Sandy.

There was much work to be done to get their new house in order. There were trees to clear and stumps to blow up. Robert ended up breaking his arm while working on his new home, but he never let it slow him down.

Mr. and Mrs. Nichols threw a party for them to celebrate their new house. About twenty people showed up to the party to help them celebrate. Seven days later, tragedy would hit this family and their new home.

It happened at 5:30 a.m. while most of the family was asleep. Ethel, their daughter, was upstairs sleeping in the bed she shared with her cousin Glady Roe. Richard was sleeping in his bed. The youngest, Harold, was sleeping as well.

Inace was busy at the stove making breakfast for her family. Robert and Earl were sitting at the table talking. Earl excused himself from the table. He told his father he was feeling ill and that it must have been something he ate. Earl left the table and walked outside. Moments later, the house exploded.

Albert Johnston heard the explosion. He said multiple windows shattered on his house from the explosion, and the first thought he had was, *oh no, the dynamite in my barn must have gone off*. Johnston got dressed and headed outside to see what had happened. His barn was perfectly intact. Looking around, he eventually figured out where the explosion came from. It came from the house he had just sold to a nice family.

Albert Johnston ran toward the house. He was stopped by Richard Jones, the middle son, who was still dressed in his nightclothes. Richard begged Albert to go for help. Albert told Richard to rouse all the neighbors while he went to what was remaining of the house to give immediate help.

Before Richard took off to rouse the neighbors, Earl showed up from behind them, the same direction as Albert Johnston's house. Earl told Albert that he was walking to work when he heard the explosion. Earl worked at the Bear Creek Dam of the Bull Run Project, as did his father. This information contradicted the other report that it was only moments after he left the table that the explosion happened.

Earl and Albert headed toward the house, which was in shambles. It was quite the horror scene. Harold Jones, the youngest in the family, was the first family member they found. Sadly, he was near death. His body was found practically lifeless, his head crushed in. He was lying on his bed that had been blown outside the house.

The next to be found was Inace, pinned under her still flaming stove. She had a broken leg and one of her arms was nearly torn from her body. She was losing a lot of blood.

The father was found where the kitchen used to be. His face was cut up and his ankle and hip were broken, but he was alive.

Ethel, the daughter, and Glady were found with only minor injuries. The family pets were not as lucky. A white dog, a guinea pig and a cat were all dead. Their dog Laddie, a big collie, made it through the explosion and was found wandering around, confused and sniffing at torn bits of clothing.

Albert Johnston's wife of ten years, Freda, showed up on the scene, and she, Albert and Earl started to help the injured. Albert and Earl lifted the stove from Inace Jones and tried to slow down the blood rapidly flowing from her body.

Freda picked up Harold, wrapped him in a blanket and set him away from the wreckage. It was clear that he was not going to make it, and he passed within the hour.

Richard Jones must have done a good job rousing the neighbors, or maybe the explosion alerted everyone. Either way, within a half hour there were fifty neighbors on the scene, including Dr. Adix of Gresham. A call was made for an ambulance, but it would not arrive for another three hours. Within that time, Harold passed and Inace was in bad shape. When the Red Cross showed up at 10:00 a.m., it was clear that she also would not make it, and she died in the ambulance on the way to Good Samaritan.

Times were different back then. At this point now, the scene, be it either a crime or an accident scene, would be taped off and the public would not have access to it so that the evidence would not be disturbed. But this was not the case in Boring in 1928.

The first thing to happen was that Albert went to his house and got his horse and began hauling out beams so they could find the source of the explosion and aid the other townspeople, who were building temporary covers using the wreckage to put any salvageable belongings undercover for the family. After moving away some heavy timber where the kitchen once was, he discovered where the explosion originated. He found a large hole that was eight feet across and three feet deep.

The next day, the newspapers came out with pictures of the wreckage and photos of the family members. According to the papers, the original theory was that the explosion was caused by a kerosene lantern blowing up. This was proven not to be true when the kerosene lantern was found dented but intact. Plus, anyone who knew about explosions knew that a kerosene lamp

Dr. Adix was born in Louisiana but moved to Oregon when he was eight years old. Before moving to Gresham, he spent many years in Estacada, where he practiced medicine and was even mayor for a time. *Courtesy of Gresham Historical Society.*

could not destroy a whole house in this manner. A kerosene lantern can burn a house down, but it does not level a house. It was at this point that everyone began assuming it was dynamite.

This led to a couple of questions: Was it an accident? And who was responsible?

At this point, the stories of Earl Jones started to get around. How he had stolen his father's car a few months back. How they had argued about Earl not being able to go to that basketball game. For a lot of people, this made sense as motivation, and Earl became the main and only suspect.

While the rest of his surviving family was in the hospital, Earl was taken to jail. He was questioned by Sheriff Ernest Mass. Ernest was about sixty at the time. He had become sheriff for the second time a couple of years before after a ten-year gap after losing to Sheriff Wilson in 1915. The first time Mass ran for sheriff in 1911, he put wanted posters for himself around town that read: "Wanted! Reward! E.T. MASS FOR SHERIFF. Age 44, Height 6ft., Weight 240lbs. Reward-Efficiency, Competency and Honesty."

Earl, like many young men who have been arrested, said a lot of dumb things that only made him look like more of a suspect, and all of this was released to the papers.

When Sheriff Mass asked Earl about his birth mother, he told the sheriff that she died at his birth. Then Earl added that four of her sisters had been in the asylum. This led to headlines like "Earl Jones Says Asylum Houses 4 Aunts" and "Suspect in Blast Hints at Insanity." Earl's brother Richard was questioned about Earl's sanity. He said that he had never noticed any unusual behavior.

Earl also asked the sheriff if he could collect the insurance money. This seemed suspect to many people and pointed to premeditation.

Earl was asked about the problems with his father and how his father would not let him out at nights and they fought about him not being able to go to the basketball game the week before. Earl confirmed this all to be true.

Eventually, Earl admitted that he had purchased the dynamite and placed it under the house. But he denied many times the accusation that he was the one to set it off. One time, after being asked if he set it off, he replied with the snotty "I don't remember setting it off, Sheriff. If I do, I'll let you know."

At this point, Earl did not have an attorney. He had no one to guide him, not even his family, because those who survived were all at the hospital. If he was guilty, then you tend to think, *Yeah, do not get him an attorney yet. Let him keep talking. He will hang himself.* But if he was not guilty, there was an explanation for the way he was talking. This was a young man who did not know any better. He was quite upset about his whole life being blown up. He had lost family members, and on top of all that, he had people treating him like he did it. In that situation, how could you not be upset? How could you not try to find relief from the pressure by giving obnoxious responses or saying sarcastic things?

Mr. Pace, who was both the coroner and the mayor of Oregon City, said that he would be getting an attorney for Earl and added, "If this attorney insists upon the release of the prisoner or the placing of the charge against him, the charge will be placed, and it will be first-degree murder."

A grand jury interviewed witnesses on the case. They talked to Sheriff Mass, Pace and a young lady named Irene Schweitzer, who was said to be Earl's sweetheart. They also interviewed a few of his neighbors, including Lizzie Duggard, J.E. Sieser and W.F. Eddy, the deputy sheriff. Lastly, they interviewed Earl Jones.

The grand jury indicted Earl Jones on a charge of first-degree murder. Sheriff Mass was the person to let Earl know, to which Earl's response was, "That is just what I expected."

While this was all going on, the surviving family members were recovering in the hospital, except for Richard, who had only minor injuries. But he was spending most of his time at the hospital with his family.

Things were touch and go for a while with Robert. The *Morning Oregonian* wrote that he was in serious condition and that grave doubts of his recovery were expressed. A description of his condition in the hospital was described. It was said that he laid on a cot in a large ward. His left leg, which was broken in four separate places, was trussed up in weights, and his face and arms still carried ugly gashes and cuts from the flying timber. His left eye was lacerated, but doctors did not think it was destroyed. At this point, it was swollen shut.

The deaths of his wife and child were kept from Robert for three days. The fact that his eldest son was a suspect was also kept from him and the other injured family members. When Robert was well enough, he was told about the deaths of his wife and child and was asked to give his recollection of the incident. When he told the story, he never even hinted that he thought Earl had any involvement.

This is how he described what happened in his own words:

> *I was sitting at the table in the dining room when I heard the roar. Mother was in the kitchen. They tell me the explosion seemed to come from under the floor, and I guess that is why she was killed. It must have been a bomb, yet I can't understand how anyone could have set it off it seems so inhuman. I thought at first that it was the gasoline lamp, but they tell me now that the lamp could not have caused such an explosion, and I guess they are right. It seemed to me, though that whatever happened right underneath me. I thought it was the actual explosion that shattered my leg. But I guess it must have been some of the timbers. It all took place so quickly that I can't remember. They tell me I was blown through two walls, but the first I knew was when Earl came running over to me and tried to get me out from beneath some of the timbers, he finally did so when he got help.*

He was cautiously questioned about Earl's whereabouts during the explosion, with the questioners trying not to let Robert know that Earl was a suspect. Robert's response was, "He told me this morning, he went to one of the outbuildings, that he was standing in the door of the building when the

explosion occurred. He must have been because he was the first one to reach me. He had gone out of the house without his cap and coat."

This is, of course, a different account than the one from Albert Johnston that Earl had passed his house when the explosion happened and that he was heading to work.

Robert did not find out about the suspicion placed on his son by any officials. He found out from Inace's mother, Laura Ethelda Roe. Most of the family simply called her Grandma. "Robert, they think Earl did it," Grandma told Robert. He responded, "No, Earl couldn't have done it, I know he couldn't have done it. Why if they pin that onto Earl, it'll be worse than if all of us had been killed. I can't imagine how it happened. But I know this much, and that is that Earl's innocent."

When asked about Earl possibly being mentally ill, Robert said that he sometimes acted affected, which was his word for acting weird. He also confirmed that Earl's mother had a strain of insanity in her and that four of her sisters were said to have been in asylums. Not wanting this to be taken as confirmation of Earl's sanity status, he added, "But Earl was never criminally inclined."

Grandma must have believed the rumors because she pushed a little more, telling him, "They say that you and he quarreled and that he had words with you the morning the house was blown up."

"That's absolutely a lie," Robert declared.

Earl and I always got along fine together. There were never any words, though his stepmother used to joke with him, they got along fine together too. We were at the table together that morning. Earl said he had eaten something that didn't agree with him. That's all he said. Then he got up and went outside. The explosion came right away after that—too soon for Earl to set it. Anyway, where did he have any dynamite?

Grandma then broke the news to Robert that Earl had admitted to buying a box of dynamite and placing it under the house. Robert could not dismiss this part right away. He sat stunned for a moment before mumbling, "Well, that's what happened alright that dynamite went off. I thought it was under the house because my ankle and heels were broken." Not accepting that Earl could have done it on purpose and trying to build an excuse for him, he added, "I wish he would have told me about it. I wouldn't have let him put it under the house. We had talked about getting some dynamite to blow some stumps around the house and I suppose that's how he came to get it."

Robert's daughter, Ethel, and niece Glady were also in the hospital. They were in much more stable condition than Robert was. Both just had cuts and bruises.

Ethel said it was like a dream. "I heard a buzzing roar, so I must have been awake at first. Then I started to go up. I have often felt that sensation when dreaming—just going up and up." Glady agreed with Ethel, responding, "That's just the way I felt." Ethel continued, explaining what happened: "We were sleeping together downstairs and we went up together and came down with our feet together, though our bodies were lying in different directions. Everything seemed to fall on top of the us—the mattress the bedding and the springs and I don't know what else." She added, "Yes, it was just like a dream, but it certainly had a quick and bad ending."

Richard was there at the time that Ethel and Glady were asked about it, and in response to them saying it was like a dream, he said, "Same here, although I don't think I was awake." He later explained his experience during the explosion. He said that he was asleep upstairs when the explosion happened and was tossed forty feet from the house.

While Earl was in jail and the family was in the hospital, the Boring Odd Fellows, the lodge of which Robert Jones was a member, raised money for the burial and funeral of Harold and Inace. The funeral took place seven days after the explosion. It was quite a somber event. The sky was overcast, and the threat of rain was there all throughout the ceremony. It is unknown if the injured Robert Jones was able to go to the funeral of his wife and son, but the incarcerated Earl Jones was there. During most of the funeral, it was said that he showed no sign of emotion.

It was reported that several hundred people attended the service, and many of those viewed the bodies. Some of those who attended were the townspeople, schoolmates of Harold, members of the Sandy Grange, members of the Boring Rebekah Lodge and of course the Odd Fellows who arranged for the funeral. The Odd Fellows were known for their motto: "Visit the sick, relieve the distressed, bury the dead and educate the orphan."

The Odd Fellows would have all been wearing black with crepe rosettes of the color of the highest degree they had in fellowship, with a sprig of evergreen pinned above it. They also wore black in memoriam ribbons to honor the dead.

The pallbearers were friends of the Joneses. For Mrs. Inace Jones, it was John Hoffmeister, Floyd Lake, Asa Lake, Oliver Peterson, Dan Erdman and J. Shonteen who carried the casket with her remains to the grave. For Harold Jones, who died at such a young age, it was a much more tragic vision to see.

Harold was a small boy, and it might have looked odd for full-size adults to carry the small coffin. His pallbearers were all schoolmates of his. It must have been bleak seeing the young Donald Rich, Marion Duley, Miles Aubin, Edwin Child, Kenneth Valberg and Robert Modine carrying his small coffin to the grave.

Reverend O.J. Gill gave the sermon. The noble grand of the Boring Odd Fellows Lodge went before the grave and gave a speech about the pleasures of life and the sadness of death. He stood in front of the mourners and began:

> *My Brothers, we have assembled to perform the last service the living can render to the departed: to pay respect to one to whom we were bound by the claims of sincere friendship, unfeigned love, and simple truth, one who was born as we were born, who lived as we now live, and for many days enjoyed his possessions, his power, and his friendships. When we lay to rest his earthly remains, with its imperfections, we will cherish a lively recollection of his virtues.*

Near the end of his speech, Gill said, "As a token that the virtues of our brother will forever dwell in our memories, we deposit this evergreen upon his casket. Farewell, Brother, until we meet thee in the Eternal Home." He then took the sprig of evergreen that was pinned to him and tossed it into the grave. Silently, all members of the lodge did the same, giving their last respects to the dead.

At the end of the service, as flowers were being scattered on the two graves, Earl started to show his emotions. His grandmother noticed and kissed him on the forehead to comfort him, but Earl broke down and began sobbing. His grandmother held him as he wept.

As the service closed, it began to rain, and the three hundred present left with tearful eyes.

Guilty or not, Earl was going to be in jail for a while. The case was to be held up until Robert Jones was healed enough to sit at the trial. Robert was a key witness and a believer that Earl was innocent, which made him quite important for the defense's case. It was clear that it was going to be a while before Robert was well enough. After a few weeks in the hospital, it was reported that he was in critical condition again.

At the end of June, after Earl had been in Clackamas County Jail for a little over three months, he was released on bail. Albert Johnston, the neighbor who was first on the scene of the explosion, put up a property

bond of $3,000 with Lizzie Dugger, another neighbor, to make it happen. Johnston even let Earl move into his home while he awaited trial.

A week after his release, an article was published stating that Robert Jones was still on his back and that the trial would not proceed until he could appear in court.

The trial would start five months later, on November 22. The charge against Earl Jones was first-degree murder. It was eight months after the explosion that destroyed the lives of the Jones family. Robert was healed enough to testify but would not attend the whole trial because he was still hospitalized.

Earl's brother Richard was the first witness on the first day of the trial. He told his version of what happened during the explosion. He told how he ran and got help from their neighbor Albert Johnston. Then he said they saw Earl approaching the Jones home from almost the same direction they had come from. It was noted that this conflicted with Earl's statement when he was arrested that he was standing in the door of an outbuilding when the explosion occurred.

Sheriff Mass was also put on the stand to tell the court and the jury how Earl had admitted to buying the dynamite and placing it under the house but that he bought it to blow up stumps around the property. Sheriff Mass added that Earl told him that not all the dynamite was used and said, "I bought the dynamite, all right. But I'll never tell you what I did with it."

Otto Meinig was also called as a witness to testify that Earl Jones bought fifty pounds of dynamite from the Meinig Store on March 7, 1928, a week before the explosion. Otto was a well-liked individual in the Sandy area. He was said to be a generous man who contributed much money to the community. He was also a charter member of the Sandy Odd Fellows, as well as a city councilman. The Meinig Store promoted fairness in its products. This slogan ran in an ad in 1907: "Our motto is 'do business on the square.' And our customers are invited to compare, weigh, measure, or count everything purchased in our store, if it isn't right, we make it right."

The court adjourned at 4:00 p.m. with an announcement that the trial would begin again the next morning at 9:30 a.m.

Day two was started with a full courtroom. Many witnesses were called on the prosecuting side, and many people made the trek out from Boring to attend this trial.

The state, represented by district attorney Livy Stipp, spent the morning presenting its case against Earl. Most of that information was circumstantial. Earl sat stolid and unmoved while they presented their case and brought up witness after witness.

Right: Otto Meinig was a second-generation store owner and a charter member of the Sandy IOOF lodge. *Courtesy of Sandy Historical Society.*

Below: Meinig Store sold all your daily needs—flour, milk and even dynamite. *Courtesy of Sandy Historical Society.*

Neighbor Charles Dykstra testified that Earl had told him, "My father is the only one who can save me," and later said, "My mother alone could save me, and she is dead."

When Deputy Sheriff W.G. Duncan was questioned, he testified that Earl had asked him about collecting the insurance.

Sheriff Mass was put on the stand again. He told the court that when he originally asked Earl if he had purchased any powder, Earl had responded, "I want to see my lawyer." Later, according to Mass, Earl admitted to buying the powder but never admitted to setting it off.

After a morning of testimony, the state closed its case, and it was then the defense's turn. The defense started by asking for a directed verdict on the grounds that the state had failed to make a case. Judge Campbell denied the motion.

The defense went right to calling witnesses after that, the first being Robert Jones, for whom this trial was postponed until he was in good enough health. He was just barely well enough. Robert hobbled uncertainly to the stand. He expressed that he did not want to lose another son and that he believed Earl to be innocent.

Freda Johnston was next to the witness stand. She was one of the first people to the scene. She testified that Mrs. Jones's face was covered with sooty dust when she first saw her after the explosion. She also described the cookstove. She stated that it was blown to smithereens except for two big dents in the bottom of the warming stove. It was the only piece intact. This corroborates with the defense's theory that the kitchen stove might have blown up first and set off the powder beneath the house. Freda also testified that Mrs. Jones regularly used kerosene to light the fire because they were using damp wood in the stove. This could explain the stove exploding, if it did, in fact, blow before the dynamite.

Adding to the stove theory, the defense pointed out that the stove was blown to bits but the heating stove, a similar distance from the point of the explosion, was battered but intact.

The defense never called Earl to the stand.

The defense rested its case after a speech from Earl LaTourette, head counsel for the defense:

> *Hang this boy or acquit him; send him to the gallows or return him to the freedom of his native hills. There is no half-way ground in this case. This boy is innocent, or he is guilty. Either he set off the blast that killed his stepmother and brother or he did not. The state has woven a chain*

of circumstantial evidence around this boy; it is for you to decide whether the key links of this chain are strong enough to drag him to the gallows. I think this story the state has built is an unreasonable story, but that is for you to decide.

This speech momentarily broke Earl Jones from his stolid state. His face flushed as he looked out the court window into the fog and then looked at the clock—possibly wondering how long until he would know his fate.

District attorney Livy Stipp summed up the case for the state briefly before the second day of the trial closed. He again accused Earl of killing his stepmother and his ten-year-old half brother. He also reminded the jury that out of all the other family members, it was Earl who admitted to placing the powder under the house and that only Earl was outside of the house at the time of the explosion.

The third and final day of the trial began with Gilbert Hedges from the defense side reconstructing the incident. Tears ran down the cheeks of Robert Jones having to hear the story again about the explosion and what had happened to his son Harold and his beloved wife, Inace.

Gilbert then tried to put the jury in the place of Earl by asking, "Would you be rational if such a catastrophe engulfed you? Here was this lad with his mother fatally hurt, his brother dead and his father and sister injured, his home wrecked." Gilbert than asked the jury to consider what motivation Earl could have:

In murder charges of this nature, it's necessary to establish a motive. What motive has the state established to indicate that Earl Jones would blast his own home and his family in it? None I say. They insinuate that he desired to collect the meager insurance on the home, but if that had been the case surely he would have resorted to fire, and what object could he possibly have had in killing members of his family?

It was then Livy Stipp's chance to make his final plea against Earl. His speech went like this:

We know that this youth bought 50 pounds of 20 percent DuPont blasting powder. By his own admission, he placed it under the house—the edge of the house. We know that later it was placed further under the house, some eight or 10 feet at a position where it would only be placed by the design of some person looking toward the demolishment of the house and the death of

its occupants. We know that Earl Jones alone knew of this powder under the house. We know that Earl Jones knew all about the powder and its handling. We believe that this powder was not exploded by accident and it is up to you of the jury to decide whether Earl Jones ignited the blast that sent his stepmother Inace Jones to her death and killed Harold, his 10-year-old stepbrother. You must decide. You must make conclusions on the basis of the testimony offered to decide as to the guilt or innocence of this youth.

Before the jury went off to make its decision, Judge Campbell gave instructions to the jury, saying that there were only five possible verdicts: first-degree murder, first-degree murder with the recommendation for life imprisonment, second-degree murder, manslaughter and not guilty.

Shortly after noon, the members of the jury started deliberating. They would not finish until almost midnight.

During this wait, most of the spectators left. Even Robert, who was still under hospital care, had to leave to get back to the hospital before the verdict was announced. Only fifteen of their Boring neighbors remained at the end.

By the end of the twelve hours of deliberation, the jurors had eliminated consideration for first- or second-degree murder and were voting for or against the conviction of manslaughter. It was reported that the jurors did twenty-five to thirty ballots, with the last being seven for conviction and five for acquittal. They were deadlocked. Earl would have to be tried again. Earl, who was known for his stolid and stoic appearance during the trial, showed no emotion when the news of the deadlock was given.

It was reported in various papers the next day that Earl was still behind bars and a retrial was likely six months away.

Another six months passed before Earl was arraigned in the circuit court, where he pleaded guilty to charges of manslaughter. He asked for immediate sentencing. The judge gave him three years. Robert Jones was quoted as saying, "I will never believe Earl is guilty and I never have, and I hope he will be paroled as soon as he is eligible."

Earl's last quote in the newspapers summed up why he pleaded guilty to manslaughter: "I am not guilty of this crime, but I am morally as I placed the powder under the house, and this caused the death of my stepmother and stepbrother. I want to start serving my sentence and get it over with."

PART III

BOYS OF BORING

ALBIN, BOY INVENTOR
AND CRIME SOLVER

The Giese family did not live in Boring for awfully long. They were still living in Portland at the time they bought the property from the Boring mail carrier, Mr. Johnson, and built a new house there. They moved into their new home in 1927 and had moved out of Boring by 1930.

Their house no longer stands, but the legend of their son still carries on. Albin was described as an eccentric kid. At sixteen years old, he was known by most of the other Boring kids as the local inventor because he was always claiming to have invented all these amazing things. Most of these inventions are lost to time. One that is not lost is when he told the other kids that he invented a way to send a letter from the Earth all the way to the moon. He gathered a bunch of kids to see its first attempt. The invention consisted of a two-inch pipe, and it was said that it blew up on its first and only attempt.

But that is only his minor legend. He is remembered in town mostly for a prank that happened to him. You see, Albin was also interested in becoming a secret service agent. He even sent away for a kit that taught lessons on how to be one. The most popular kit at the time was the University of Applied Science Fingerprint and Secret Intelligence Service course. It came with a book called *A Study of Fingerprints, Their Uses and Classification*. It also came with a fingerprinting kit. Albin was known to take fingerprints of other youths in Boring.

Some of the other young people in Boring thought this was funny and decided to play a prank on Albin. They told him that there were counterfeiters making fake money out in the woods of Boring. They said

that their operation was just a mile or so south of town and that you could follow the railroad line to where their set-up was.

This prank was bigger than just a "get him out there and laugh at him when there are no counterfeiters to be found" prank. They went all out on this prank and even got an adult to help them pull it off. He was a man named Click Humphrey who was both the operator of the local power plant and a deputy sheriff. Click was nearly forty at the time, but people described him as sort of a big kid himself. Humphrey brought along two of his buddies with him to make their presence a little more intimidating. They took a car to the spot and waited for the boys to show.

The boys were Albin, Don Rich and Al Valberg. Al and Don were both younger than Albin at around twelve years old. Al was the son of John Valberg, who owned the big sawmill in Boring at the time. Don was the son of Otis Rich, who was one of the local mail carriers. Don and Al were not victims in the prank. They were in on it. The three followed the railroad tracks a mile out of town until they got close to Seifer station.

That is when Click Humphrey stepped out from behind a power pole, revolver in hand. He yelled at the three boys, "What the hell are you guys snooping around here for?" and then he fired two shots into the air. Al and Don threw themselves to the ground and started to roll around like they had been shot, moaning and yelling.

When everybody was done having a big laugh at Albin's expense, they realized that Albin was gone. Don and Al got up and looked around, but they could not find him anywhere. All that remained of Albin Giese in the area was his hat. They found it on the ground and assumed that he must have run so fast that his hat flew right off his head.

Once they realized that they were not going to find Albin on foot, they all piled into Click Humphrey's car to head toward town to try to find him. Even though Albin was on foot and they were in an automobile, they never did catch up to him. Albin had run so fast that they had no hope of catching him. If they had, they could have stopped him from what happened next.

Albin ran all the way to town and to the Odd Fellows Hall. It was a Saturday night, and the Boring Grange was using the hall for one of its dances. Before the others could get to town, Albin had run up the stairs of the hall and burst through the doors. He then started yelling to all the people in the hall that there were counterfeiters in the woods and they had shot Don and Al. Albin tried to start a posse to go after the counterfeiters.

This could have gotten more out of control. Imagine half the town walking down the trail to find Click driving his car out in a hurry trying to find Albin.

Would he get the opportunity to explain the prank? Luckily, Click had told his wife, Mae Humphrey, about the prank. Mae was less like Click. She was more serious than her husband. In her life, she would be a justice of the peace and a teacher at the Behnke-Walker business school. Eventually, she would be the postmaster of Boring for almost forty years and the president of the National Association of Postmasters. She was involved in all those things in her life as well as being a member of the grange that was hosting the dance, and she was there that night helping with the dance. So, Mae was able to quickly calm down the escalating situation by telling everyone that there were not really counterfeiters in the woods and that Don and Al were OK and her husband and a couple kids were just playing a prank.

Chapter *11*

THE COW INCIDENT

M iles Aubin was the town historian of Boring for many years. He grew up in this town and wrote many articles for local papers in this area. When Miles wrote about this story, he did not list any names. But when I told this story at the Community Planning Organization, the son of one of the boys in the story happened to be there.

His name is Jim Valberg, and he owns the local Shell gas station. His family has a long history in the town of Boring. They owned the hardware store, they built the big two-story brick building in town and they owned a sawmill in Boring.

His dad's name was Kenneth Valberg but went by Kenny. Kenny was into sports. He played baseball growing up. He was even recruited by the New York Yankees but decided to stay in Boring and work at the sawmill. Kenny and his brother Al used to pal around with Miles and Miles's brother Lawrence. If Kenny was there, it was a good possibility that Al was there too. Al had his own wild story as an adult. Rumor has it that he would ride his horse to the local tavern in Boring, which is not that strange, especially at that time in a rural community. But one night, he brought the horse inside the tavern with him.

One of the things the boys liked to do was play in the Sunshine Valley area of Boring, an area that once had a railroad and was logged heavily before being abandoned. The railroad was pulled out, but the old trestles remained and so did the old houses that the sawmill workers used. The boys would explore these old houses looking for treasures but mostly just found old furniture, newspapers, catalogues and canned goods.

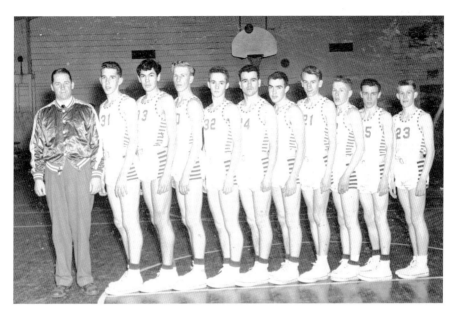

Miles Aubin was the town historian of Boring for many years and was also a huge sports fan. This photo is from 1952, when he was coach of a basketball team. *Courtesy of Sandy Historical Society.*

The boys, being the young entrepreneurs that they were, found ways to make money out of that abandoned place. Mr. Andrews who owned one of the abandoned houses gave them an old rusty shotgun. They took it to town and sold it for fifty cents.

Cascara bark was another way they were able to make some money. At this time, the pharmacists would buy cascara bark to make laxatives. The boys would spend many days peeling those trees to sell the bark for twelve cents a pound. The boys lost interest when the price dropped to three cents a pound.

The boys would also help local farmers. One day, they were driving some cows all the way from Hogan road to the Haley area, about a two-mile walk through the Sunshine Valley area. If they were smart, they would have avoided the old train trestles masquerading as bridges. At that time, they were quite decayed. But the boys decided to try their luck and take the cows across, as it would save them some time.

The bridges were unsafe. At an earlier time, Mr. Putkamer was hauling wood across that very bridge with his team and wagon. When he was halfway across, a rotten piece of wood gave away, and his horse's foot went through it. The horse started thrashing around so badly that Putkamer had no choice but to unhook his horse or he was going to end up losing his whole

Miles Aubin and Kenny Valberg in the eighth grade. Both are in the back row. Miles is the first from the left and Kenny is the fourth, the younger-looking boy with the tic. *Courtesy of Sandy Historical Society.*

wagonload. Once unhooked, the horse ran off the edge of the bridge and fell to its death.

The boys took the cows across, and one of the cows stepped on a seven-inch crack. Just like Putkamer's horse, the cow's leg went through the wood. The cow would not go any farther. It had three legs on solid ground; it should have been able to pull out one leg.

The boys thought about their situation. Unlike Putkamer's incident, the animal they were taking across got its foot stuck in the start of the bridge. So the boys decided that one of them would go underneath the bridge and push the cow's leg up. The cow did not appreciate her leg being pushed. It was said that she expressed her displeasure onto the boy's head that was underneath the bridge doing the pushing. Once done, she lifted her own leg and continued across the bridge.

When Kenny Valberg retold this story, he liked to set the scene by saying, "It was in the springtime, and the cow manure was nice and green." Except he used a more colorful word for manure.

Chapter *12*

I SWEAR THERE WAS A SQUIRREL!

After a hard day of work, the loggers were taking the train from the woods back to Maguire's logging camp to rest for the evening. It was a short four-mile trip that they had taken many times before. But this time, when they were close to the town of Boring, they heard a gunshot and then two more shots in rapid succession. One bullet went into the shoulder of one of the workers. Another went through the back pocket of another man. This frightened him but caused no injury. The third shot was later discovered embedded in the side of the train.

Instead of speeding off like one would think the conductor would do, the train slowed down to find out what was happening. Luckily, the shooter did not take this chance to fire more shots.

A couple of hours later, Sheriff Wilson was on the scene, as he always was in those days. But the man who captured many moonshiners, the Wild West Gang and even the Wild Man of Kelso could not find any trace of evidence of who fired on the train. The motivation of the attack was a mystery and was the question on everybody's mind. The man whose back pocket was grazed by the bullet was of no help in the sheriff's inquiry. It was said that he was too frantic from the experience to give any intelligible information.

Two days later, the *Oregon City Enterprise* ran the article "Deputy Hughes Gets Youth That Shot Up Train." The boy was named Foster Rea McMains, but most people called him Red. He was fourteen years old, though some articles mistakenly refer to him as being twelve. Red went to Boring Grade School, and he had just gotten a new .22-caliber high-powered rifle that he was eager to try out. According to Red, he was out with his new gun when

he spotted a squirrel. When he saw the squirrel, he got excited and quickly brought his gun up and shot three rapid-fire shots at it. Red claimed that he did not see the train when he shot and that he did not know that he hit it. But he did admit that he noticed the train slowing down a few hundred feet down the line. He said that after shooting at the squirrel, he had gone home and thought nothing of it until he was approached by a couple of men while he was doing chores outside of his home. He still had his .22 with him leaning against a post.

The men interrogated him, asking about the shooting. Then two more men showed up, and one of the first men told the other man that this was the boy who shot the train. This must have spooked the boy to go from doing his chores to having four grown men trying to get him to confess to shooting a train. If he did not know he shot the train, it must have been stressful, and if he had shot the train on purpose, it must have filled him with anxiety as well.

Later that night, the boy's conscience got to him, and he told his father about the squirrel and the men coming by. The father decided that they had to do the right thing and go to the police to tell their side of the story.

Red was the second child of William and Josephine McMains. William was already in his thirties when he married Josephine Garlic, who preferred to be called Josie. William was thirty-four and Josie had just turned seventeen the month before their marriage. The two were both born in Nebraska and moved from Nebraska with her parents shortly after they were married. Her father started a farm, and William would help work the farm. In the next ten years, they had three children together and moved out on their own. William became an engineer for the railroad while Josie raised the kids.

As William and Red traveled to Oregon City to talk to the police, word had already gotten around that Red was the one who shot the train. On the way, they were pulled over by Deputy Henry Hughes, who took Red into custody. Deputy Hughes was one of Sheriff Wilson's best deputies. He would go on almost every moonshine raid with Wilson. Hughes was born in Wild Rose, Wisconsin, in 1856. When the Hughes family first came to Oregon, they took up residence in Beavercreek, Oregon, where he was a farmer and ran a general store, before becoming a member of law enforcement.

Deputy Hughes had brought county school superintendent Joel Calavan with him. Calavan started his career in education at the age of twenty, when he became a teacher near Scio. He taught at various schools for the next twenty years before becoming the superintendent of Clackamas County Schools. He also brought along the country club leader, Miss Romney Snedeker, to help look for the boy. Romney helped kids set up clubs. She helped organize

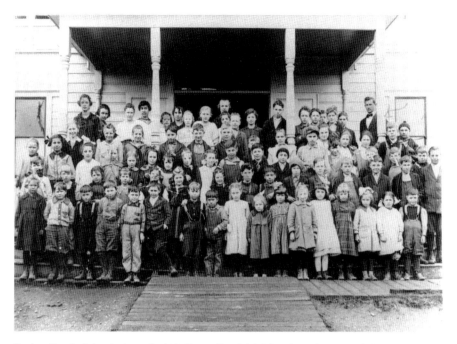

Boring Grade School, class of 1919. Foster Rea McMains should be one of the many kids pictured in this photo. *Courtesy of Sandy Historical Society.*

sewing clubs, cooking clubs, calf clubs, rabbit clubs and even pig clubs. She helped organize them and prepare them for shows and fairs. She probably organized a club that Red was in and was along to identify him.

Once the boy was taken to the sheriff's office, he was interrogated by deputy district attorney Joseph Dean Butler. Butler had recently sent another local Boring boy to a reform school. After the questioning, Red was given a court date a week later to stand before Judge Anderson.

During that time, he was able to get a letter from the superintendent of Boring Grade School affirming his good conduct and good grades. Red gave the letter to the judge and told his side of the story. The judge either believed him or just felt like the kid had gone through enough, so he dismissed the charges against Foster Rea "Red" McMains, holding that the train shooting was purely accidental.

This seems to be Foster Rea "Red" McMains's only involvement with the law. He lived a good life. He worked as an electrician in his adult life. He got married in his twenties to a Canadian-born woman named Mirian. They were married for over fifty years. The couple had two kids together, and at the time of his death at seventy-one, he had five grandchildren.

PART IV

DANGEROUSLY BORING

MASHED POTATOES,
THE HARD WAY

The first big train accident to happen in the Boring area was on March 21, 1904, and it involved a passenger train and a gravel train. The operator of the gravel train stopped at Gresham, where he got word from a superintendent identified only as Tiffany that he would be able to make it to his next stop before the passenger train coming from Boring would get there, so he would not have to wait. This ended up being bad information, and it would lead to the first train collision in Boring.

Harry Smith, the motorman of the passenger train, tried to stop when he saw the gravel train. But it was coming around a curve, which left little time to respond. With what little time he had, Harry put the train in reverse and tried to slow it down. He quickly realized that there was no avoiding the collision. So, Harry jumped from the train, getting a few bruises in the process. He was safe. His train, on the other hand, was smashed in the front, and many of his passengers were wounded from the flying broken glass. Many had cuts on their hands and faces. The gravel train took little damage. Its pilot, aka its cattle catcher, was destroyed, and its smokestack got knocked off.

The second accident to happen in Boring was much more dramatic. It happened almost a year later on March 1, 1905. The headline in the *Morning Oregonian* was "Eight Are Hurt," with a sub-headline of "Lives Saved by Motorman."

Robert Adams was the name of that motorman. He was a seasoned train operator. He had been in a situation the previous year where he had to act

quickly to save a life. An intoxicated man fell off a platform onto the tracks in front of Adams's train. His quick response to stop the train saved that man's life. That man repaid Adams by trying to fight him. An unnamed person stopped the fight by grabbing the drunk fellow by the shoulders and forcing him to sit and be calm. Then the train continued its journey.

On the day of the potato incident, Robert was taking mail car number 21 from Cazadero toward Boring and then on to Portland. The train did not quite make it to the Boring depot.

In those days, the railway was how most of the mail was moved between post offices. The mail car would often have passengers as well. Besides Robert, there were at least nine other people on the train at the time of the accident. The train crew was minimal. There was Robert Adams, of course. His conductor was Dan Miller, and the mail clerk was Walter Case. Walter had been the mail clerk on this train since service started the previous year and had worked in the railroad branch of the postal service for four years. He was nearly thirty-two years old and had just gotten married to Gertrude Linebaugh. His bachelorhood was noted two years earlier at a Thanksgiving gathering that was hosted by the Women's Club of the Railway Mail Service. It listed Walter and seven other men as representing the bachelors. Ms. Linebaugh—who later became Mrs. Case—was also at that event.

The 1101 passenger train in front of the Boring Train Depot. *Courtesy of Mark Moore.*

The Oregon Water, Power and Railway's company doctor happened to be on the train. His name was Dr. William King Haviland. Haviland wore many hats. Besides being the company doctor for Oregon Water, Power and Railway, he was also the postmaster of Estacada at the time, which might explain why he was on the mail car. At that time, the Estacada Post Office was a small operation being run out of the same office as a barbershop. The doctor also had his own practice, which was in its own business front on Main Street in Estacada. Haviland was a well-known man in Estacada. He was an alderman and was even the mayor of Estacada for two terms.

The train car had left from Cazadero at 9:30 a.m. and had already made stops in Estacada and Barton before it started up the steep incline that was called Boring Hill. It was in between two bridges at the time of the accident. It was said that if they had been on one of the bridges when it happened, they surely would have been knocked off. If they were two minutes slower, they would have been on the first bridge. Two minutes faster and they would have been on the high trestle known as the Deep Creek Bridge.

As the train headed up the incline toward Boring, the astute Robert Adams heard a heavy rumbling. He was not sure at first what the sound was or where it was coming from. His response was to start slowing down his train in case there was trouble. When he realized the sound was getting louder, and thus closer, he brought the train to a halt. That is when he saw where all the rumbling was coming from. Around a corner ahead came a runaway train car that was coming down the rail wildly and heading right toward them at full speed. Robert responded as quickly as he could to the impending danger. He slammed his train in reverse and then attempted to outrun the runaway car.

Where did the runaway car come from? It was a refrigerated train car full of potatoes left on a siding in Boring by a train for another train to come and pick up. Its original destination was California. It was reported that the brake was on, and there was even a chain attached to the brake to stop it from being accidentally released.

How the chain came off the brake is unknown. But it did, and when it did, the train started rolling, slowly at first. Once it was on the main track and heading down that incline, it started picking up speed in a hurry. The train car was moving too fast for any of the trainmen at Boring to try to stop it. All they could do was watch the runaway car head down the incline and hope there was not a train coming toward Boring at that time. As the train gained speed, it was getting wildly out of control. The car had more than a mile of downhill momentum to go before it would meet the mail car. That was

plenty of time to get going so fast that no matter how skilled the motorman was or how fast he responded, a collision would be inevitable.

As Robert Adams reversed the train to avoid the collision, the conductor, Dan Miller, jumped into action and worked on getting all the passengers up and out of their seats. With little time to spare, he was able to move all the passengers to the rear of the train to where the mail was kept.

W.A. Jones and his wife were on the train. They were both residents of Estacada, where Jones had a feed and livery barn. He was also a member of the Amusement Club of Estacada, a group that mostly put on dances. For New Year's, the club had just held its Grand Hard Time Ball, where it raised money for uniforms for the athletic department of the club.

The other passengers were described in the papers as Swedish workmen. They were W.H. Ullyart from Columbia City; Matt Lomen and Henry Dorst from Portland; Andrew Liebe from Baker City; and David Higgins, a local from Eagle Creek, a town between Boring and Estacada.

As Dan Miller was getting the passengers to the mail car, Robert Adams pushed the train as hard as he could, trying to build momentum in reverse to put as much distance between his train and the rapidly approaching runaway car as he could. The potato car was practically flying down the tracks toward their train. The race to outrace the potato car only lasted 250 yards before the unavoidable happened. The potato car smashed into the mail train, and according to the *Oregon Journal*, the mail car was hurled from the tracks. But that is most likely not true, because both *Estacada News* and the *Morning Oregonian* wrote that neither car left the tracks. The mail car was the one that took the most damage. The front of the mail car and its vestibule were severely damaged.

The train and its vestibule were not the only things to take on damage in the wreck. Most of the passengers were injured. The crew was mostly unscathed. Robert Adams and Dan Miller were OK, as was Dr. Haviland, who was well enough to be able to help with some of the injured. Walter Case, the mail clerk, on the other hand, was seriously hurt. His collarbone was dislocated after he was thrown into the corner of the mailroom from the force of the wreck.

Being thrown by the force of the wreck was most of the passengers' experience, and they all received injuries from it. Ullyart had a fractured rib and cuts on his head and hands. Matt Lomen got a cut on his heel as well as some bruising, and it was said that he had possible internal damage. Dorst just had some scratches and bruises. Liebe had numerous cuts and bruises. Higgins had some cuts on his head but was mostly just shaken up by the

incident. W.A. Jones had cuts on his head and face, as well as body bruises. His wife was listed as injured as well.

Although there were a lot of injuries, it was believed that none of them would be fatal. Robert Adams got himself to a phone and telephoned for assistance. S.G. Fields was sent on a special car to the scene of the accident. That special car was used to take the injured to St. Vincent's Hospital in Portland.

Though Walter Case's injuries were described as the worst, he walked himself into the office of Dr. Darling, where his injuries were treated, and then made his way back home on his own.

Most of the others were also released and able to go home that same day, except W.H. Ullyart and Matt Lomen, who would need more time to recover.

They were all in good hands at St. Vincent's Hospital. They were being treated by leading Portland surgeon Dr. Alpha Rockey. According to a biography of him that was written into the paperwork for his home to be put in the National Register of Historic Places, Dr. Rockey had a reputation on the national level as a medical authority. He was serious about being a great surgeon. He was trained at Hanneman Medical School and Rush Medical School, both respected schools in Chicago. He also would travel to other countries to study under famous surgeons. He traveled to London, Paris, Berlin, Vienna and Cairo.

Because of Robert Adams's quick response, the people inside the train all survived and the train was not destroyed. It was able to be driven back under its own power to the shop to be repaired so it could be put back in commission to deliver the mail. Neither snow nor rain nor runaway train car full of potatoes...

Chapter 14

THE TRAGIC LIFE OF
A SAWMILL WORKER

The lumber industry has always been a dangerous one to be in. This was even more true in the past, before the safety standards we now have set up to help protect people in the industry. The first possible injury to happen at a Boring sawmill was in 1891.

This occurred at the Last Chance Sawmill, which was on the outskirts of what is now known as Boring in an area that was starting to be called Nob Hill. Back in 1891, the area was not known as Boring yet. The Boring School had been established years before, but the name had not quite stuck for the whole area yet.

The first reference to Nob Hill was in the June 3, 1891 issue of the *Oregon City Enterprise* in the local interest section, which gave little updates on what the residents were up to. It was the first communication from this new area, and it already contained two incidents at sawmills. The name Nob Hill did not stick, and it might possibly be because of what was written in the July 10 issue of the *Oregon City Enterprise*. Under the Canby section was this small blurb: "We are pleased to see a communication from Nob Hill, but as we have a real interest in that piece of real estate, thus christened, we would suggest a more lonely name."

The first incident at a mill that was mentioned in that first communication from Nob Hill was that Harland Cone, one of the owners of the Last Chance Sawmill, had caught his hand between a log and a saw. Luckily, all he had was some bad bruising, and he only had to take a few days off.

The person in the other incident was not so lucky. Edward Laboron had moved from Kansas the previous year and was working at Hoyt's sawmill on

Nob Hill. Laboron and Mr. Hale went out in the millpond onto the peeled logs. The logs were slicker than they thought, and they both ended up in the water. Hale, after many failed attempts to get hold of one of the slick logs, finally got a good enough grip to pull himself out of the water. Many of the other men at the sawmill came to help try to rescue Laboron, but they were unsuccessful. It took the men thirty minutes to get his body out of the pond.

In 1903, Orville Palmer, A.J. Linton and Ralph Duniway incorporated Boring Junction Lumber Company. This was a huge operation. They controlled eight hundred acres of land. They planned to have a general sawmill, lumber and logging businesses and to buy, sell and lease land. They planned to operate railroads and tramways and build wagon roads. The company had a capital stock of $25,000. The town did boom in this period, and they accomplished a lot of their goals.

But it would not come without tragedy. Two men would be hurt in that first year badly enough to be written about in the newspapers.

In that first month, a man named Perry McGee got his hand in the way of a circular saw. He was taken to a doctor in Pleasant Home named Dr.

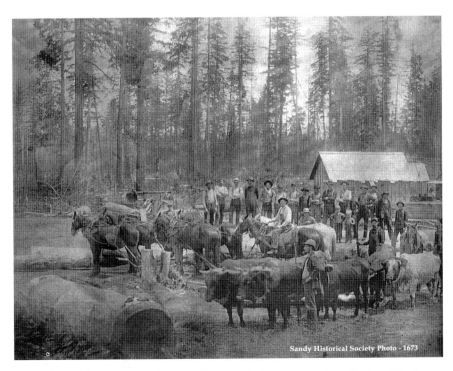

The Boring Junction Lumber Company in the early days of operation. *Courtesy of Sandy Historical Society.*

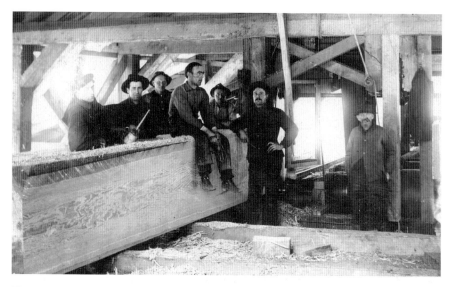

The men take a break from the hard work for a photo at the S.P.H. Lumber Company. *Author's collection.*

Powell. The doctor saved as much as he could, but he had to amputate all the fingers down to the knuckle joint.

Five short months later, Andrew McClung would be the second person to get injured at the Boring Junction Lumber Company. Andrew was born in Ohio in 1851. He lived in Nebraska and Kansas before finally moving to Oregon, where he would spend the rest of his days.

The headline in the *Oregonian* was "Crushed by Falling Lumber." Andrew had the misfortune of a lumber pile being dropped on him, pinning him between it and another pile of lumber. His left leg was broken right above the knee. His right ankle was broken too. He also dislocated his right elbow. The worst injury was the four broken ribs that pierced his lungs. After all the lumber was pulled off him, he was taken home to recover. Dr. Joseph Short of Gresham was quick to arrive at Andrew's home. The doctor was hopeful that Andrew would recover if there were no complications from the wounded lung. Andrew did recover and lived another twenty years. He passed away on Christmas Day in 1923.

It was said that he had family in Boring that would take care of him, as would the owner of the sawmill. There must not have been any bad feeling between Andrew and Orville Palmer, the owner of the sawmill, because a few years later Andrew's son Oscar would marry Orville's daughter Grace.

Oscar worked in the sawmills as well, and just like his father, he was hurt at one too. He had an incident when he was working as a carriage tender. While he was working, a log was being turned and the overturn hook came loose and flew in his direction. Oscar threw up his arms to protect himself, which helped protect his face from taking the brunt of the force. But it did not help one of his arms, which took the force from the overturn hook. It hit him right below the elbow, crushing his arm. He also got a large gash in his head. He was taken to Gresham to get his wounds taken care of.

The next accident after Andrew McClung's to be mentioned in the papers was eight months later in the *Oregonian*. The headline was "Boring Mill Employe [*sic*] Injured." A man whose name is given only as B. Sullivan was working at one of the mills in Boring. While on the job, he accidentally cut into his left arm, severing the large tendon. It was stated that saving the arm would be almost impossible. Sullivan was taken to the St. Vincent's Hospital to be taken care of by Dr. Bryon E. Miller. No update on his condition was ever given in the papers.

In 1905, there were no reported sawmill incidents in the papers. The main Boring Junction Lumber Company was down for four months of that year after it had cut down all the lumber that the mill had a contract for.

In 1906, there was a drowning at the Boring Junction Lumber Company. The victim's name was Carl Olson, and he fell into the millpond while working on the logs. Little was known about the man. He had no known relatives in this country. He was thirty-one years old and unmarried. An inquest was held and found that it was an accident. Since Olson was Swedish, his body was given over to the Swedish consul in Portland. Where his body went after that is unknown. A search of Find A Grave reveals no clues of where he was buried.

The year 1907 was a bad one for Orville Palmer's sawmill operation. At some point, the name changed from Boring Junction Lumber Company to Boring Lumber Company. In January 1907, the Boring Lumber Company burned down, losing the sawmill and the contents within. By March of that year, Orville Palmer had built a new sawmill. It was a modern mill that would increase production. When he rebuilt, Palmer put in a 250-horsepower engine to run the plant.

The only injury in the papers that year was covered in the *Oregon Daily Journal*. The article from September 1907 explains that G.B. Prettyman was in bad condition. He had been involved in an accident several months prior at a Boring sawmill. He had gone through several surgeries since then to fix his foot and leg that were damaged. Things were not looking good at the time of the article, as Prettyman had blood poisoning.

There is one account in Boring of a visitor of a sawmill getting himself hurt as well. His name was Walker Proctor, a man who would one day be the mayor of Sandy. But at this point in his life, he was co-owner of the Sandy Fir Lumber Company, a large sawmill located on Tickle Creek near Sandy, Oregon.

Proctor had made the journey to Boring with a wagon pulled by a team of horses. He was there to get some materials that his sawmill needed. After loading up in Boring, he was ready to make his trip back to Sandy. But the Jonsrud brothers were in his path, moving their steam-powered donkey engine. Proctor saw the cable on the ground, but it was not moving at the moment, so he decided to take his team and wagon across it. But as soon as his team started over the cable, the power was switched to that cable, which spooked his horses to the point that they almost flipped the wagon. Proctor was able to get the wagon in control, and once stopped, he went over to the engineer to find out what the big deal was. As they had their discussion, a side cable snapped and, with much force and weight, came right toward Proctor.

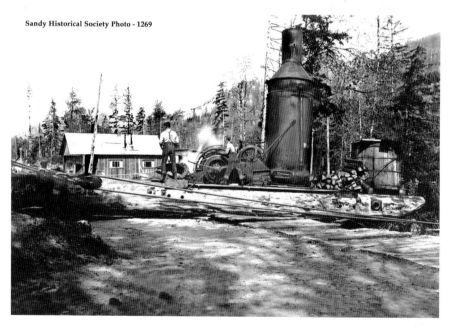

Sandy Historical Society Photo - 1269

The donkey steam engine owned by the Jonsrud brothers. *Courtesy of Sandy Historical Society.*

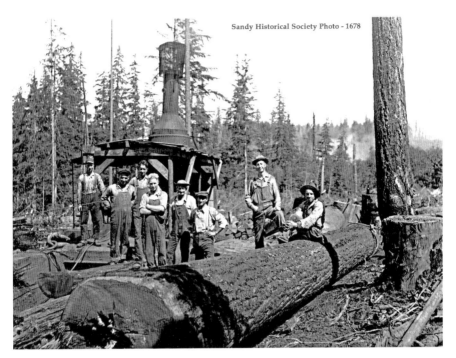

Sandy Historical Society Photo - 1678

A group of loggers from the Jonsrud-Gunderson Labor Company. *Courtesy of Sandy Historical Society.*

When the cable hit him, he was thrown forty feet from where he stood. He landed on a fence and was knocked senseless. Proctor was taken to his home, and a doctor was called. He was in critical condition, but he regained consciousness.

There would be many more accidents at the sawmills in Boring over the rest of the century. Logging is still to this day considered one of the most hazardous fields in the United States. According to the CDC, there were seventy-three deaths in 2010 in the logging industry. There were many different sawmill operations in Boring that came and went, including the Last Chance, Hoyt's, the Hard Up, John Doyen's mill, Stone and Rodlin's, Chaney Mill, Bruss Mill, Jarl & Page Bros Mill, Gerlinger's, Linderman's, the Davis sawmill, Jonsrud Bros., Johausen Lumber Company, Tie Company Mill, S.P.H. Lumber Company, the Hillyard Bros., Maguire's logging camp, Harris Stud Mill and Summit Mill. The most well-known mills in Boring were the Boring Lumber Company, Valberg Lumber and Vanport. Vanport is the only one in operation currently, though it is no longer a mill. Vanport still has an operation in Boring but is now in the wood exporting business.

MURDER PLOT AT THE SAWMILL

L ittle is known about Harnam Singh, or was it Bingwan Singh? That depends on which newspaper you read. Not much is known about him except for the couple days he lived and worked in Boring and the couple days he stayed at Good Samaritan Hospital. One newspaper stated that he had only been in this country for two weeks at the time of the incident. According to various articles, he was Hindu, but at this time in history, many people who were Punjabis or Sikhs were labeled as Hindus in newspapers. Since we cannot be completely sure, the term *East Indian* will be used. *Hindu* will be used from time to time if it is a reference to the specific source material.

Harnam and his brother Sporan and another unnamed East Indian man showed up in the town of Boring on a Wednesday, the day before Halloween 1907. The three men were looking for work and ended up at Jarl & Pagh Bros. Mill, just south of Boring. The mill did not have three openings at the moment, but it did offer Harnam a job, which he started that very afternoon. The mill promised jobs for the other two soon. They were given a bunkhouse to live in, but it was isolated from the other workers.

Harnam got the job of off-bearing from a large rip saw. Though he spoke no English, he did seem to understand the job. His task was a tough one. Off-bearing just means to carry away. This was a large ripsaw, which meant large pieces for Harnam to carry away.

The three men were not welcome among the other millworkers. Many men were not pleased about the hiring of them and spoke about it in the open.

The following evening, Halloween night, while the three men were sleeping in their bunkhouse, they awoke to the sound of gunfire. They could tell right away that it was not just one person firing. The shots came too fast, and the sounds of the shots differed. It was said that the men used revolvers, rifles and shotguns in their attack.

The shots stopped suddenly, and there were two explanations given for this. One is that someone in the bunkhouse screamed in agony. The other is Mr. Pagh, one of the mill owners, ran outside after hearing all the gunfire. His residence was only three hundred feet from the Singhs' bunkhouse.

With the gunfire seeming to have stopped, Pagh approached the bunkhouse. When he opened the door, he found two of the men crouching in the corner in fear while Harnam was lying on the floor in agony. Pagh could see that Harnam was gravely wounded and could very well be dying. Pagh quickly went to Boring to get Dr. McElroy. Dr. McElroy dressed his wounds and took care of him until morning, when he was put on the Oregon Water and Power train and taken to First and Alder, where an ambulance was waiting to take him to the Good Samaritan Hospital.

At the hospital, Harnam was examined by a physician, who found that he was shot in the thigh by a 25-30 bullet from a rifle. The bullet had entered through the back fleshy area. His leg was badly shattered, and it was thought that amputation would be necessary to his survival.

Constable Bert Jonsrud of Boring was one of the first to go out to the scene to investigate. He was only part time in law enforcement. His main source of income came from running a four-horse logging team, transporting logs for various mills in the area. At the scene, he found several different types of shells from different types of guns; rifle, shotgun and revolver shells were found. He found several 25-30 shells and shells from a 25-30 Marlin rifle that was believed to be the weapon that shot the bullet that entered poor Harnam. Without revealing who was the suspect, the papers wrote that the owner of the rifle was known because there were shells found that the constable recognized because they were copper-sheathed bullets. A warrant for the known assailant's arrest should be issued immediately. Being that Harnam and the other two East Indian men spoke no English, officers would have to find an interpreter before they could try to get any information out of them.

The *Morning Oregonian* expressed fear that this might affect relations with Great Britain, stating that we have treaties with Great Britain for which we guarantee protection to "her" subjects. This article also contained lines that you would not see in a paper today, such as, "The Hindus cannot be classed as desirable citizens, and it is a matter of great regret that they are here," and

"The failure to furnish this protection could easily be worked up into a very serious offense especially if the British were as 'Touchy' over such matters as the Japs have been."

Governor Chamberlain was notified by Clackamas County authorities of the enormity of the offense. They recommended prompt action to apprehend the gunmen.

At the hospital, Harnam was not doing well. He already had one operation where some of the larger pieces of his shattered thigh bone were removed. But Dr. McCormick urged Harnam that for him to survive this, they would need to amputate his leg. Harnam was unsure about this. The newspapers ran articles with headlines like "Hindu at Boring Refuses to Allow Amputation of Shattered Leg," "No Faith in Surgery" and "Prefers Death to Amputation of Shattered Leg." The newspapers also mentioned that Harnam had only been in this country for two weeks and had no knowledge of modern surgery.

Two weeks in this country! Think of all the planning and effort it took for Harnam to get over to this country. How he had dreams of building a new life in America. He was starting a new journey to better his life by coming to the land of the free. But what happened instead? He got shot by racists within a month and might possibly die. This must have affected his feeling about America. How did his brother and their companion feel? Did they still want to live their American dream, or was the beautiful image of America tarnished for them?

Nobody was able to convince Harnam to get the limb removed. He declared that he would die if it was necessary. His decision to not get the amputation changed this case in a big way. If he did not get the limb removed, there was a slim chance of his survival. If he died, this became a murder case.

There were six men arrested by Constable Bert Jonsrud as suspects in the attempted murder of Harnam Singh: Walter St. Clair, John Riley, Earl Ransier, William Dickenson and his two sons, John and J.M. Dickenson. There was also a warrant for the arrest of Vernon Hawes.

With the arrests came more information, and various articles were written about the case. Some articles downplayed the situation. There were distasteful headlines like "Halloween Prank Proves Serious Affair," "Drunken Hallowe'en Prank" and "Hallowen'en Hoodlums Made a Murderous Assault on the Bunkhouse." This wasn't a Halloween prank. Only the attention-grabbing titles used the word Halloween. The suspects never stated Halloween motivations.

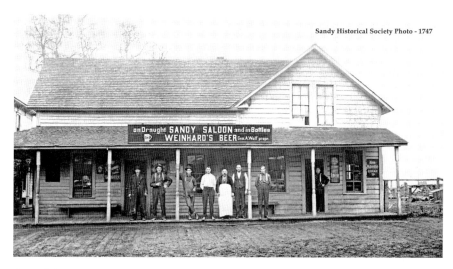

Sandy Historical Society Photo - 1747

One of the saloons operating in Sandy at the time of the incident. Just like in the town of Boring, Weinhard's beer is heavily advertised on the front of the building. *Courtesy of Sandy Historical Society.*

More of the story was revealed in these articles. It was revealed that all seven men—the six caught and the one they were looking for—were lumberman at local mills and that they resented the "Hindus" being at the camp.

According to an *Oregonian* article, this was premeditated. But it was plotted under the influence of booze. The seven men had traveled to Sandy to drink in a saloon. There they got drunk and plotted how to chase the Hindus away.

The men would not admit their intentions as murderous. They said they just wanted to scare them. But they did load up on guns and ammunition. They had a 25-30 Marlin rifle, a revolver, a Winchester shotgun and even a muzzle loading shotgun, which they brought to a hill that overlooked the shack that Harnam and the two others were residing in. Once there, they opened fire.

It was written that at first, they were just shooting above the cabin. Then one of them shot a bullet into the roof. After that, the men grew frustrated that they were hearing no outcry or response from the cabin. That is when they decided to take deadly aim and started shooting into the cabin. Once they heard the cry of Singh, they stopped shooting and took off to their homes.

The court was quick to start their case. As soon as they were arrested, the courts scheduled a hearing with them on a charge of assault with the intent to kill. During the hearing, they were questioned by the justice of the peace Torkel Jonsrud. Torkel was born in 1835 in Norway and was about seventy

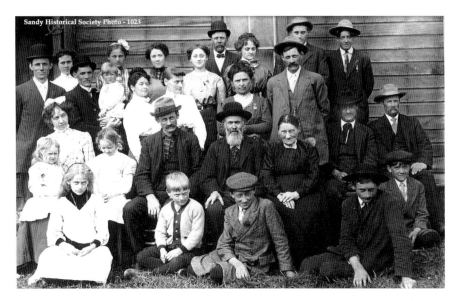

Nearly the whole Jonsrud family in one photo. Torkel is the man in the second row with the long beard. Bert is listed as being in this photo as well, but which person is him is unknown. *Courtesy of Sandy Historical Society.*

years old at this time. His family had moved from Norway to Minnesota in 1854. During his time in Minnesota, he would serve as an officer in the Civil War. In Minnesota, he would get his law degree and even served as a senator in the Minnesota legislature. Torkel was the father of the constable who arrested the men. According to Phil Jonsrud in his book *Eighty Years in the Same Neighborhood*, "The family joked that the law was 'all in the family" and that Torkel sentenced the bad guys and Bert hauled them into the pokey in Oregon City." In that book, Phil recalls that his parents had said that Torkel was the more lenient one and that Bert had a calming manner.

District attorney Gilbert Hedges and deputy district attorney Oscar Eby were notified. But only Oscar Eby was in attendance. The six men all gave their stories, were held on a sum of $250 each and were to appear before the circuit court.

The Dickensons, the father and sons, were able to get bondsmen and were released. They went back to their home in Boring, where it was said that they were well known. St. Clair, Riley and Ransier were transients and could not afford the bail, so they remained locked up.

Later that day, Harnam Singh died, which changed things, making it a murder case. The Dickinson brothers were arrested once again the following day by Constable Jonsrud.

Now Vernon Hawes was the last suspect not incarcerated. A couple of days later, he turned himself in to Sheriff Robert Beatie in Oregon City. He claimed that he had gone to McMinnville soon after the shooting and did not know about the warrant for his arrest. This was nearly five days after the warrant was issued and three days after his name was in the papers as a suspect.

There was a preliminary hearing a few days later and then another special term of court in mid-January where the men all pleaded not guilty.

Two separate trials were scheduled. On January 27, six of the men together were defended by Attorney George Brownell. George Brownell was born in New York, and that is where he passed the bar exam. He had been living in Oregon for sixteen years at the time of the trial. Brownell was a much respected and successful lawyer. The other trial would be for Vernon Hawes, and it was scheduled for February 5.

The trials continued to be postponed until April, after Attorney George Brownell got sick.

The main trial began on April 22, 1908. Prosecutions attorney was Dan Malarkey and the district attorney was Gilbert Hedges, whose objective in the trial was to establish by evidence that the men went to Sandy and became partially intoxicated and then came down to the sawmill with guns and, taking a position behind the cabin of the Hindu, fired shot after shot until finally one of the bullets struck the unfortunate man.

Vernon Hawes, whose trial is never mentioned again, would be the state's main witness, and it was declared that he would get an "immunity bath" for his testimony. They were in the middle of his questioning when the trial was adjourned for the day. Most suspected that the trial would be wrapped up the next day. During that first day of the trial, they were able to establish that racial prejudice was the reason for the action of the men.

Much more was revealed on the second day of trial. It was revealed that Vernon Hawes for his help in this trial would be never be brought to a trial of his own.

William Dickerson was the only one who fired into the cabin. It was brought up that his father, who did some of the shooting, did not shoot into the cabin either but was encouraging and did nothing to stop him from shooting shot after shot into the Hindu's home.

The two surviving East Indian men told how they had crouched behind furniture in the scantily furnished one-room shack while shots were fired into the building. That was until Singh was hit, screaming out, and the firing stopped.

One side story was that the other men did not like being in the same trial as Sinclair, who had a reputation as a hard character and who several weeks ago earlier made an unprovoked attack on a jail guard named Peter Nehren.

The closing argument that afternoon of the second day of the trial was given by Attorney Dan Malarkey, special prosecutor for the state. In his address to the jury, he made several arraignments for the defendants, going over their actions again, including the drinking and the shooting up of the cabin.

The jury retired at 3:30 p.m. to deliberate. At 9:00 p.m., the jurors had yet to make a decision and asked for a repetition of the judge's definitions of the different degrees of murder.

At 11:00 p.m., they requested to look over some of the evidence again. At midnight, the jury was still out, with little prospects of reaching an agreement before morning.

After deliberating for thirteen hours, the jury members came to their conclusion for the murder of Harnam Singh. Their verdict for William, the only one who shot into the cabin, and his father, who was encouraging of shooting into the cabin, was second-degree murder. The other three men were convicted of manslaughter. For the conviction of second-degree murder, they were given imprisonment for life. For manslaughter, the penalty was one to fifteen years imprisonment.

For Ransier and Riley, the jury asked for the mercy of the court. Sentencing for them would be pronounced the following week. There was also a hearing scheduled that week for Walter Sinclair. Walter Sinclair pleaded guilty at the hearing to manslaughter. He was given six years.

The court sentenced Ransier and Riley to three years in the penitentiary but paroled them. The judge talked to the two of them firmly but with kindness. He told them to lead good lives but warned them that any attempt on their part to break their parole would be punishable by the immediate execution of their sentence.

For the youngest Dickenson, John, the judge told him to go home to his mother and take care of her.

After the court was adjourned, it was said that John Dickenson, Ransier and Riley went to the judge's chambers and thanked him for leniency with tears in their eyes and assured him that they would not abuse this second chance.

In the end, only three of them saw jail time—Walter Sinclair and the father and son.

J.D. Dickenson, the father who was implicated in the murder, and his son William, who pulled the trigger on that shot that went into poor Harnam, were handcuffed together and walked up the street from the county jail to Southern Pacific depot to make their way to Salem to start their life sentences. The father smoked his pipe along the way.

TOWN BURNS,

FIRECRACKERS BLAMED

By April 1922, Boring had built itself up from a small mill and a small train depot to a full-fledged thriving town. The small train depot was replaced by a large two-story building with American Express Company signage placed above the Boring sign. There was W.R. Telford's Merchandise, where you could get all your daily supply needs without having to make the trip all the way to Portland. The town had at least two churches by that time, the Methodist Episcopal church and the Baptist church on Haley Road. The single-room schoolhouse had been replaced with a two-story, four-room school that had an attendance of about eighty children. The post office had moved from operating in W.R. Telford's Merchandise into its own building across the road, and attached to it was now a drugstore called Morand Drug Co.

On the east side of the main road through town was a complex of four buildings. The Waller Building had a pool hall, barbershop and confectionery. The Telford Building, owned by Wallace Telford, housed a garage and living quarters that Francis Morgan lived in. One of Francis's previous enterprises was running a stagecoach service between Sandy and Boring. He was also a police chief in Sandy for a short period, only one month. At this time, Francis owned a business in one of the other buildings in the four-building complex. He owned the theater that was located above the Boring Auto Truck Company's garage, which was operated by Shaver and Yeon. The Boring Theater was still an exciting novelty for the people of Boring. The license for it had been acquired only a month previously,

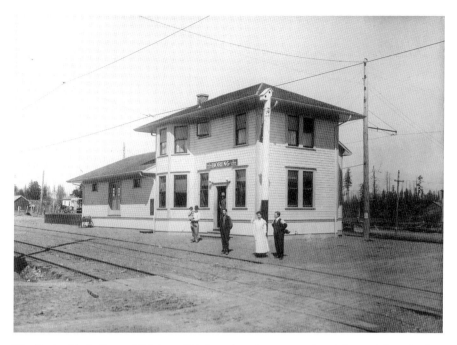

The Boring Train Depot. This beautiful depot is no longer standing; it burned down in the late 1920s. *Courtesy of Sandy Historical Society.*

though the equipment for it had been purchased the year before. The final building of these four is the Knox Building, which had a photo studio/ gallery upstairs and a shoe repair shop called Van Dolin's Shoe Shop on the street level. These four buildings were the ones affected the most by the fire of 1922.

The fire occurred on April 13, 1922. It was a Thursday night, which meant the Boring Theater was showing a film. The theater did not show daily movies; they only were shown on Thursday nights. It was around 9:00 p.m., and most of the other businesses were already closed for the night. There was estimated to be around fifty to seventy-five people in the theater enjoying the weekly show.

The fire did not start in the theater, but since the building that the fire started in was closed, the people in the theater were the first to notice it. A man who worked at the confectionery was in the theater when he happened to look out from the show and noticed a weird light in the corner of the room. He got up and hurried to the corner to discover that the light he saw was in fact fire and it was spreading at a rapid pace. Seconds later, smoke began to fill the theater.

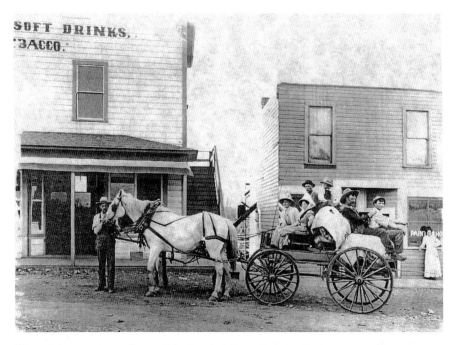

The only known photo of any of the four buildings. *Author's collection.*

He ran back to the theater and warned all the moviegoers about the fire. They all hurried out of the building, escaping before the theater went up in flames. The people in the theater were quick but orderly getting out, and no one was injured exiting the theater.

At first, nobody knew what to do. They were all too wound up from the experience to take any action yet. They could see that the Waller Building next to the Theater Building was already on fire. This is possibly when the town realized that the fire originated in the Waller Building. With the Waller Building burning, this meant no more pool hall, barbershop or confectionery shop.

The cause of the fire is not exactly clear. In the April 21 issue of the *Oregon City Enterprise*, there are two articles on the front page of the paper about the fire. One claims firecrackers were the source, and the other one asked Burt Waller, the owner of the building, what the cause was, and he said that he could not account for the origin of the fire.

The *Gresham Outlook* had stated that they were told that there was a light left on in the corner where the fire had begun and that was possibly the cause. There was also a stove in that room but in a different corner than where they thought the fire started. Another article supports the firecracker narrative.

The April 14 issue of the *Oregon Daily Journal* states, "It was believed that a burning cigar or cigarette stub, left near the firecrackers when the pool room was closed for the night, caused the fire."

As the theater burned above the Boring Auto Truck Company, cars that were stored there were driven out to safety. They were either not quick enough or the fire spread too fast, because they did lose two of their trucks and supplies valued at $3,000.

Those working at the Boring Auto Truck Company were not the only people scrambling to rescue items from the buildings. While his theater burned, Francis Morgan ran upstairs in the Telford Building, where he and his family lived. They were able to rescue a truck and some bedding, but all their furniture burned. In the panic to get out of the building, Francis got himself hurt by tripping and falling down the stairs on his way back out.

It was said that Burt Waller went up to his residence to save some of his personal items as well. This must have been even more harrowing since he lived above the pool hall where the fire originated. Later, Burt Waller would

Sandy Historical Society Photo - 1001

Boring Town Baseball Team - 1921. Front row, from left: Al Hoffmeister, Allan Burt Compton, Alton Lovelace, Burt Waller, Sponsor - Waller's Pool Hall & Confectionary in Boring) Walt Hoffmeister, John Hoffmeister, and the star pitcher from Portland. Back row: DeYoung, Amsberg, Otis Rich, Manager Guy Dugger, Lester "Pick" Irvin, and Andy Gribble.

Burt Waller had many enterprises in Boring. He was also involved in local sports. He is the older man in the front row holding the two baseball bats. *Courtesy of Sandy Historical Society.*

claim that he lost a trunk that was upstairs in the fire and that it contained papers and $500 worth of gold and silver.

There was not much that the townspeople could do to save the burning buildings, but they tried. First, they called the Gresham Fire Department. One person ran over to the Metzger garage and retrieved a small chemical fire extinguisher and tried to use that on the fire, but the liquid gave out quickly, and what little progress was gained was lost from the southwest wind that was fanning the fire. The only close water source was upstairs in the buildings that were burning. A hose was stretched from the train depot, but the hose put out so little water that it was found to be useless.

Gresham tried to bring out its fire apparatus, but the wagon could not make it because of the conditions of the road leading to Boring. The Sandy Fire Department was called as well, but it could not make it to Boring either because the roads between Boring and Sandy were just as bad. They did not give up. A bunch of firefighters from Gresham armed with buckets piled into three cars and made their way to Boring. Some Sandy firefighters also made their way to Boring via automobile.

The last building to catch was the Knox Building, which housed the photo studio on top and Van Dolin's shoe shop on the bottom. This gave Mr. Peterson long enough to save his furniture from his upstairs photo studio.

Even with the wind coming from the southwest, it was starting to look like the fire was going to set the west side of the street on fire. Across from the raging fire were the post office and William Morand's house. Morand was the postmaster, and he built his house right next to his post office. The heat from the fire had already broken out the front windows of the post office and blistered the paint. Then the flames caught the roof of Morand's house on fire.

At that time, the Gresham Fire Department made it to Boring and formed a bucket brigade. Firefighters were able to put out Morand's house and then went on to the task of wetting down the roofs of all the other nearby buildings. Because of the quick action of the bucket brigade and the help of the wind, no other buildings burned.

During the peak of the fire, it illuminated the sky, and the fire could be seen from parts of Portland until about midnight.

No lives were lost that day, but all four buildings burned down. The town lost its confectionery, barbershop, shoe shop, photo studio, pool hall, a couple of garages and its one and only theater. No fact seems to surprise people from Boring more than telling them that Boring had a theater. Boring had a theater, but it only lasted a month before burning to the ground.

The Boring youth basketball team. Fourth from the left is Billy Morand, son of William and Amy Morand, the second and third postmasters of the town. *Courtesy of Sandy Historical Society.*

Original estimates for the loss were $10,000 to 12,000. But once everything was accounted for, all four buildings, equipment and vehicles were estimated to be a total loss of $15,000, which would be a quarter million dollars in today's currency.

The following Thursday, even though the theater had burned down, Boring still had its Thursday night show. The movie was shown at the Odd Fellows Hall. It was said that the Odd Fellows Hall would show a movie every Thursday until a new theater could be built. But it was never built, and eventually, the Thursday night movie in Boring was a thing of the past. The Rebekah Lodge, the sister fraternity of the Odd Fellows, had a basket sale to raise money for new uniforms for the basketball team whose uniforms burned in the fire. The uniforms were in Burt Waller's building because he was also involved in youth sports.

Most of the businesses would not be rebuilt—no new theater, no new shoe shop, no new photo studio. The Boring Auto Truck Company would remain in business for years to come.

Burt Waller said that he would rebuild his pool hall, and he did. He also had a dance hall that he ran that would get him in trouble from time to time for staying open too late and for people being caught drunk on the premises.

He eventually lost his license but continued to stay open. One night in November 1922, Sheriff Wilson went to Waller's dance hall and busted a man named Arthur Gray for being drunk. It was also three hours past midnight, and licensed dance halls were supposed to be closed by midnight. But Waller was trying to use the club loophole. Before they even pulled his dance hall license, he had gotten a club license under the name Boring Amusement Club. Its members could go in for their one-dollar member fee. The sheriff's department said that this loophole would not hold up because this so-called amusement club only provided one form of amusement, dancing, which made it a dance hall.

Today, where those buildings used to stand is the two-story brick Valberg Building and the Timber Tavern. Throughout the years, things have changed in Boring. The train depot is now gone, burned down in the late '20s. The train tracks were pulled out in the early 1990s. But the town remains a beautiful place filled with interesting people, and we still have our great old buildings. James Roots Store that was built in 1906 remains, now called McCall's. William Morand's post office that he built in 1913 is still there, now known as Boring Bar. The town may never have gotten another theater, but you can go with your neighbors to see live theater by the Nutz-n-Boltz Theater Company in the grange hall.

BIBLIOGRAPHY

Adjutant General's Office. *Roster and Record of Iowa Soldiers in the War of the Rebellion, Together with Historical Sketches of Volunteer Organizations, 1861–1866.* Des Moines, IA: E.H. English, state printer, 1911.

Amend, Robin. "A Certain Grace." *Nostalgia Magazine*, November 2000.

Aubin, Miles. "Bachelor Lane and Telford in the Twenties." Unpublished research.

———. "Sunshine Valley." Unpublished research.

Clackamas County News. "Children's Party at Boring." November 2, 1928.

———. "Earl Jones Given Three Years in Jail." April 12, 1929.

———. "Hard Times Party Draws Large Crowd." January 31, 1941.

———. "Lodge Plans Clam Feed." September 21, 1928.

Clackamas County Record. "Lumber Company Incorporated." March 23, 1903.

Eastern Clackamas News. "Funeral Held for Mother and Son." March 23, 1928.

———. "Mystery Still Surrounds the Wild Man of Kelso." March 23, 1916.

———. "Party for Jones Family." March 09, 1928.

Encyclopedia Britannica. "Tommy Burns." June 13, 2020.

Estacada News. "Accident on the Railroad." March 2, 1905.

———. "The Amusement Club Met Last Night." December 9, 1904.

———. "Local Interests." January 31, 1907.

Gresham Historical Society. *Gresham Stories of Our Past: Campground to City*. Gresham, OR: Gresham Historical Society, 1993.

Gresham Outlook. "Allow Me a Few Words." October 18, 1914.

Hines, Harvey Kimball. *Illustrated History of the State of Oregon*. OR: Lewis Publishing Company, 1893.

Jonsrud, Phil. *80 Years in the Same Neighborhood*. N.p.: Sandy Historical Society, 2002.

Medford Mail Tribute. "Two Days Only." February 6, 1914.

Morning Enterprise. "Three Men Injured at Mill Near Boring." August 6, 1912.

———. "2 Boys Thought Thieves Are Shot." February 11, 1913.

Morning Oregonian. "Alleged Moonshiners Held to Jury." September 4, 1920.

———. "Begin Hindu Murder Trial." April 23, 1908.

———. "Big Liquor Haul Made." April 24, 1920.

———. "Blast Kills Two; Son, 19, in Custody." March 16, 1928.

———. "Blast Survivors Hear Grim News." March 20, 1928.

———. "Boring Employe [*sic*] Injured." May 11, 1904.

———. "Boring Lodge Buys Property." April 15, 1916.

———. "Boring Rebekah Lodge Instituted." December 5, 1913.

———. "Boys Shot by Farmer." February 11, 1913.

———. "Charge Is Murder." November 6, 1907.

———. "Clackamas County." January 6, 1908.

———. "Crushed by Falling Lumber." August 14, 1903.

———. "Earl Jones Faces Trial for Murder." November 23, 1928.

———. "Earl Jones Sentenced." April 9, 1920.

———. "Eight Are Hurt." March 2, 1905.

———. "Electric Cars Collide." March 3, 1904.

———. "Explosion Suspect Released." July 2, 1928.

———. "Guilty of Murder Charge." January 23, 1908.

———. "Hindu Fears Knife." November 3, 1907.

———. "Hindu Shot by Fellow Workman." November 2, 1907.

———. "An Illicit Still Was Seized." August 30, 1920.

———. "Indictment Made in Boring Blast." March 22, 1928.

———. "Jury in Murder Case Still Out." April 25, 1908.

———. "Liberty or Death Asked for Jones." November 24, 1928.

———. "Lodge Using New Hall." March 10, 1913.

———. "Lost His Hand." March 10, 1903.

———. "Married at Boring Thursday." November 27, 1904.

———. "Moonshine Inquiry Promises Sensation." May 5, 1920.

———. "Moonshine Raids Made." October 16, 1920.

———. "Murder Trial to Open." November 3, 1928.

———. "New Town Springs Up." October 21, 1902.

———. "7 Boring Buildings Destroyed by Fire." April 14, 1922.

———. "Still Is found in Cave." August 29, 1920.

———. "Suspect in Blast Hints at Insanity." March 17, 1928.

———. "3 in Liquor Case Freed." December 30, 1920.

———. "Vernon Hawes, Wanted for Shooting Hindu, Comes Back to Jail." November 9, 1907.

———. "Violation of Prohibition Law Charged." August 31, 1920.

National Register of Historic Places from "OMB NO. 1024-0018." October 31, 1985.

Newberg Graphic. "Don't Ad." October 30, 1891.

———. "Local Events." June 25, 1897.

———. "Local Events." October 1, 1897.

Oregon City Courier. "Murder Charge against Seven." November 8, 1907.

———. "Wild West Club Is Short Lived." April 10, 1919.

Oregon City Enterprise. "Canby." June 10, 1891.

————. "Captain of Wild West Club Is Sent to Reform School." April 11, 1919.

————. "Firecrackers Start $12,000 Fire at Boring." April 21, 1922.

————. "Fire Damage in Boring Is Placed at $15,000." April 21, 1922

————. "Local Interests." May 7, 1909.

————. "Logging Train Fired on from Ambush as Men Return to Camp." January 30, 1920.

————. "Man Nymph Is Found Crazy in Boring Woods." March 17, 1916.

————. "Nob Hill." June 19, 1891.

————. "Rum and Mash Are Taken in Raid Near Here." December 24, 1920.

Oregon Daily Journal. "Boring Business Houses Burned." April 14, 1922.

————. "Carloads of Aliens, Ordered Deported, Departs for N.Y." December 14, 1921.

————. "Carl Olson Drowned in Boring Mill Pond." July 12, 1906.

————. "Nearly a Fatal Accident." October 1, 1902.

————. "One-Armed Orchestra a Feature." February 11, 1911.

————. "Pettyman May Lose Limb." September 16, 1907.

————. "The Realm of Music." May 7, 1911.

————. "Society." December 5, 1903.

Oregonian. "Carrier Delivers Mail Despite Accident." May 11, 1916.

————. "Change in Rural Delivery." July 8, 1908.

————. "Civil War Veteran Marries." June 6, 1915.

————. "Death Claims Reuben Frank." October 2, 1949.

————. "Liquor Trial Is Set." January 16, 1921.

————. "Mrs. Rachel Wolfe Dies at Philomath." August 15, 1913.

————. "Operator of Still Tells All in Court." January 25, 1921.

————. "Prisoner's Friend Held for Threats." January 21, 1921.

————. "Train Fired On; 1 Injured." January 28, 1920.

————. "Veteran Braves Storm." February 10, 1917.

Oregon Journal. "Noses Detect Liquor Odor; Still Raided." August 29, 1920.

————. "Six People in Hospital." March 1, 1905.

Oregon Mist. "Advanced Department." April 1, 1910.

————. "Kenneth Specht Shot." February 14, 1913.

Oregon Statesman. "Jones Weeps at Burial." March 3, 1928.

Peterson, Cathy. "The Oregon State Reform School." *Statesman Journal* (Salem, OR), December 27, 1991.

Rogue River Courier. "Wild Man of Kelso Has Been Captured." March 12, 1916.

Sandy Pioneers, Early Settlers and Barlow Road Days. Sandy, OR: Sandy Pioneer & Historical Association, Inc., 1993.

Sunday Oregonian. "Earl Jones' Trial Ends in Deadlock." November 25, 1928.

————. "Guilty in Second Degree." April 25, 1908.

————. "Just a Quitter." February 26, 1905.

————. "Orchestra Is Unique." February 12, 1911.

————. "Shooting Held Accident." February 8, 1920.

ABOUT THE AUTHOR

 ruce Haney has often been referred to as the town historian for Boring. He gives a monthly speech about the history of Boring and runs a popular history group called Boring Oregon History.

Bruce lives in Oregon, where he enjoys spending time with his friends, going to local theater and spending much of his time behind a computer researching the history of the town of Boring, his family tree, the history of rock-and-roll and whatever else he is currently interested in.